MW00634196

HIDDEN
HISTORY
of the
OUTER
BANKS

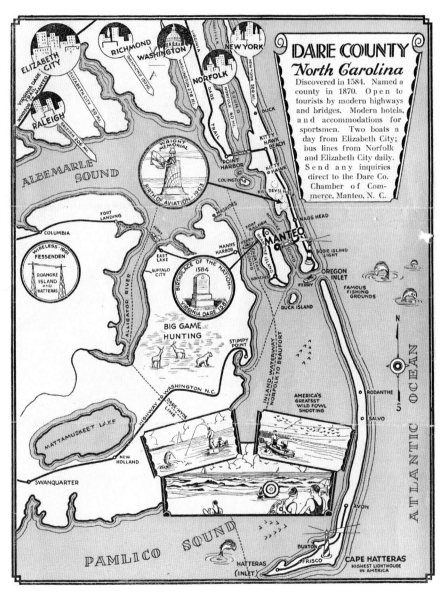

Promotional map of Dare County created by the Dare County Chamber of Commerce. The Outer Banks were originally promoted as the Dare Beaches or the Dare Coast. *Outer Banks History Center Collections, circa 1931.*

HIDDEN
HISTORY
of the
OUTER
BANKS

Sarah Downing

THE
History
PRESS

Published by The History Press
Charleston, SC 29403
www.historypress.net

Copyright © 2013 by Sarah Downing
All rights reserved

Cover: Windmill on Hatteras Island. *H.H. Brimley Collection, State Archives of North Carolina, circa 1900.*

First published 2013

Manufactured in the United States

ISBN 978.1.60949.914.3

Library of Congress CIP data applied for.

Notice: The information in this book is true and complete to the best of our knowledge. It is offered without guarantee on the part of the author or The History Press. The author and The History Press disclaim all liability in connection with the use of this book.

All rights reserved. No part of this book may be reproduced or transmitted in any form whatsoever without prior written permission from the publisher except in the case of brief quotations embodied in critical articles and reviews.

CONTENTS

CONTENTS

Acknowledgements

The bulk of *Hidden History of the Outer Banks* is based on a local history column that was published in the *Outer Banks Sentinel* newspaper in 2007, "And There Was the Time," reprinted courtesy of the *Sentinel*. The column, although short-lived, was popular. Many of the articles needed updating, as change is inevitable along the Outer Banks, where tide and time keep a steady pace.

A whole heap of folks need to be thanked for their assistance with the publication of this book. Roanoke Island native Wynne Dough, former curator of the Outer Banks History Center in Manteo, North Carolina, shared many lesser-known stories about the Outer Banks and early in my career fostered my interest in the history of my adopted home. The late author and historian David Stick unselfishly shared his time and memories with me for many years. KaeLi Schurr, current curator of the Outer Banks History Center, nurtured me and encouraged me to write.

I am blessed to have a wonderful group of friends and mentors who are area natives or have been here for decades. They always have time for my questions, and if they don't have answers, they put me in touch with someone who might. Randell Holmes, Bill Harris, Lynda Midgett, LeVern Davis Parker and Danny Couch, I am truly richer for knowing you. Thank you.

My friend and fellow lover of history Penne Sandbeck is always willing to listen and offer advice and encouragement. Jami P. Lanier, archives

technician for the National Park Service, allowed me to peruse the NPS Outer Banks Group photographs. David Miller shared his collection of memorabilia from *The Lost Colony*. LeVern Davis Parker shared her family's papers, scrapbooks and memorabilia. Sue Green Frazier helped with proofing, and Wilton C. Wescott provided my publicity photo.

J. Banks Smither, commissioning editor for North Carolina books at The History Press, was a joy to work with and made the project more fun than it should've been. I would also like to thank my husband, Steve, and my family for being supportive and putting up with the "kooky writer in the family."

Kim Andersen and Mathew Waehner at the State Archives of North Carolina, Raleigh, and Stuart Parks and Tama Creef at the Outer Banks History Center were of great assistance in fulfilling photographic orders.

Finally, a special thank-you to a great group of ladies known as "the Sistas." Their friendship, support, love and encouragement mean the world to me.

INTRODUCTION

North Carolina's Outer Banks, a slender string of barrier islands jutting into the great Atlantic, are today a bustling vacation destination and home to thousands. In the last twenty-five years, growth and development have transformed this once commercially modest area into a year-round economy offering amenities as varied as auto parts stores or reception venues for a destination wedding.

In addition to natural beauty bolstered by the sand, sea and sun, the Outer Banks have a remarkable history, beginning in 1584 when English explorers came and attempted to settle on Roanoke Island in a land race for New World territory fueled by Spain's presence in Florida. Before 1584, Algonquian Indians were seasonal visitors, using the bounteous waters for sustenance and gathering foodstuffs from the maritime forests.

The "sand banks," as they were first known, were well suited for raising livestock. Early settlers used the natural borders of the ocean and the sounds—shallow bodies of water to the west. Navigating the sounds and inlets created a population of expert boatmen. As maritime trade grew just off the coast, the land and the seascape of the Outer Banks changed accordingly; shipwrecks, lighthouses and lifesaving stations became part of the identity of this special place.

A few years before the Wright brothers made their first flight at Kill Devil Hill in 1903, a group of men formed the Roanoke Colony Memorial Association with the goal of memorializing Roanoke Island's

sixteenth-century English colonists and their mysterious disappearance in 1587. On December 17, 1903, the Wrights' twelve-second flight became a new touchstone for the region. Dare County would adopt the motto "Birthplace of a nation, birthplace of aviation."

With these two famous historic firsts, coupled with the recreational opportunities offered by the area's beaches, it wasn't long before folks in northeastern North Carolina realized that providing access to and "opening up" the Outer Banks would bring prosperity to the entire region. Although the Albemarle's gentry had summered at Nags Head before the Civil War, the beginning of Outer Banks tourism began in the 1930s. Bridges were built, roads constructed, dance halls raised, land purchased and subdivided and chambers of commerce created as landowners, business operators, developers and new residents angled for visitors. The trend toward tourism took deep root; today, there are families who have vacationed on the Outer Banks for three or four generations.

This book is a collection of images and vignettes about this area's past. Some stories have national significance, and others can only be described as esoteric. Because it is so diverse, I believe that everyone can find interest in some aspect of Outer Banks history. New tales are always being discovered about the past, just as the Outer Banks' windblown sands are always uncovering hidden treasures.

The Goodliest Land, 1584–1899

The Original Natives: Carolina Algonquians

Flashback to 1584. Captains Phillip Amadas and Arthur Barlowe have sailed from England on the first of the Roanoke Voyages. Upon arrival, they are greeted by local natives. Barlowe reported, "The next day there came unto us divers[e] boats and in one of them the king's brother, accompanied with forty or fifty men, very handsome and goodly people and in their behaviour as mannerly and civil as any of Europe. His name was Granganimo, and the king is called Wingina, the country Wingandacoa (and now, by Her Majesty, Virginia)."

Barlowe was two for three. He got the names of the native and king right; however, the country was not called Wingandacoa. This word actually meant, "you wear nice clothes," which he had heard more than once from the Indians.

Granganimo and Wingina were Carolina Algonquians. The Native Americans of North Carolina are classified by language group—Siouan, Iroquoian and Algonquian—and it is the southernmost Algonquian Indians who first came in contact with English explorers on Roanoke Island in the 1580s.

The Algonquians were found along the East Coast as far north as Canada. Their ancestors were a nomadic people who roamed in search of big game ten thousand years ago. Archaeologists refer to that

period in their history as the Paleo-Indian period. A major climate change caused the big game to die off. Traditional food sources lost their habitats, but advances in hunting technology allowed the Indians to hunt smaller game. Combined with the introduction of additional gathered foods, this moved the people into a cultural phase known as the Archaic period.

By 1584, the Carolina Algonquians were in the Woodland period, as were most natives living in North Carolina in 500 BC. This era was marked by advances such as the use of pottery, agriculture, dugout canoes, bow and arrows and the establishment of permanent settlements.

They grew pumpkins, beans, squash and melons, but corn was their primary crop. Four varieties were grown, and they ripened at different times. Their environment provided them with ample hunting opportunities for large game such as bear and deer and small game such as rabbit and squirrel, as well as waterfowl.

The bounteous waters of the ocean, rivers and sounds provided the Indians with another source of food: the fish and shellfish that constituted an important part of their diets. Fruits, nuts and roots were also gathered, dried if necessary and then stored for later use.

Several tribes or societies of Carolina Algonquians were known to exist, many of whom had more than one town or settlement. The Chowanokes dwelled along the Chowan River; the Weapemeacs and Moratocs lived on the north and southeast sides of the Albemarle Sound, respectively; the Secotans inhabited the region between the Albemarle and Pamlico Sounds; the Pomeiocs lived along the south side of the Pamlico River; and the Neusioks lived along the Neuse River. The Chesepians, who inhabited what is today southern Hampton Roads, were also part of the Carolina Algonquians as opposed the Powhatan Confederacy of Virginia to the north. Two Algonquian towns, Pemioc and Secotan, were depicted in watercolors by John White.

The Algonquians faced pressure for survival with the onslaught of colonial settlers. There was conflict for agricultural and hunting lands. Having no natural immunity to European diseases, many Indians fell prey to sickness and death. Others were enslaved or absorbed by the new culture or left the area altogether. It is estimated that by 1700, only

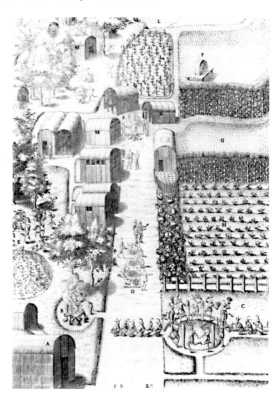

The Algonquian village of Secotan, illustrating homes and methods of planting crops. Engraving by Theodore De Bry from a John White watercolor. *Library of Congress Collections.*

five hundred Native Americans were living in the northeastern North Carolina. Some members of the Croatan and Mattamuskeet tribes ended up on a reservation in Hyde County in the 1720s. Deed research shows that a few Croatans might have still been living on Hatteras Island as late as 1800.

The Carolina Algonquians' influence will endure as long as their words are found in Outer Banks geography. William Powell's *North Carolina Gazetteer* attributes many place names to the Algonquians. Kitty Hawk is most likely derived from Chickehauk, an Indian place name found on eighteenth-century maps. Hatteras is thought to mean "there is less vegetation." Part of Chicamicomico alludes to "sinking down sand," while Currituck has probably evolved from the Algonquian word for wild goose, *coratank.*

HISTORIC ACCOUNTS OF FISHING THE OUTER BANKS

Commercial and recreational fishing have long been a part of the fabric of Dare County. Surveys of the area's visitors consistently list fishing as an important part of their Outer Banks experience, but by no means are folks of the twenty-first century the first to take advantage of the natural resources of local waters. Many references to the necessity and abundance of fishes to both native and immigrant people are recorded in histories of northeastern North Carolina.

Some of the earliest accounts of fish and fishing come from the artist/observer team of John White and Thomas Harriot, Englishmen employed to observe, document and record plants, animals and native inhabitants with which they came in contact as members of the Roanoke Voyage expeditions during the 1580s. Europeans were eager for testaments from the New World.

White's watercolors include one of a flounder, which he described as "a foot and a half in length." Likewise, on his painting of a red drum, he noted that there are "some 5 foot in length." In his painting entitled *The Manner of Their Fishing*, White presents a scene illustrating the fishing methods of the Algonquian Indians, which Thomas Harriot also described in *A Briefe and True Report of the New Found Land of Virginia*, published by Theodor de Bry in 1588: "One is by a kind of weir made of reeds which in that country are very strong. The other way, which is more strange, is with poles made sharp at one end and shooting them into the fish...either as they are rowing their boats or else as they are wading in the shallows for that purpose." These weirs that Harriot mentioned were a type of trap made by placing reeds or sticks across a body of water. A few openings were left in the setup; however, they didn't lead to open water, but rather to an enclosed area from which the fish could not escape.

North Carolina's first surveyor general, John Lawson, who surveyed and documented characteristics of the state for its proprietors, made many references to the large numbers of fish and their importance to Indians and colonists alike. In Lawson's 1709 *A New Voyage to Carolina*, he wrote, "The bluefish is one of our best fishes, and always very fat. They

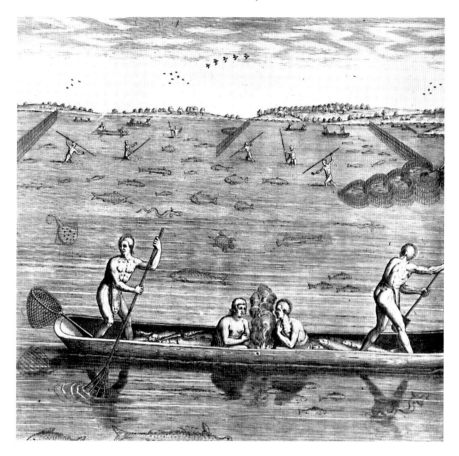

This sixteenth-century engraving by Theodore De Bry shows Algonquian methods of fishing with weirs and spears. It was made from a watercolor by artist John White, who documented Native Americans and plants and animals during the Roanoke Voyages. *Library of Congress Collections.*

are as long as salmon, and indeed I think, full as good meat. These fish come (in the fall of the year) generally after there has been one black frost, when there appear great shoals of them." Lawson continued, noting, "The Hatteras Indians and others run into the sands of the sea and strike them, though some of these fish have caused sickness and violent burnings after eating them, which is found to proceed from the gall that is broken in some of them and is hurtful."

Lawson's account also mentions the prized meat of the red drum and its value to the early colonists. He reported that the fish "is of firm good meat, but the head is beyond all the fish I have ever met withal for an

excellent dish. We have greater numbers of these fish than any other sort. People go down and catch as many barrels full as they please with hook and line, especially every young flood, when they bite. These are salted up and transported to other colonies that are bare of provisions."

In addition to his accounts of drum and bluefish, Lawson took time to mention the sheepshead, which apparently was one of the more sought-after species during his time, as it is today. The fish "has the general vogue of being the choicest fish in this place." He revealed, however, that "I think there are several others full as good."

So the next time you sit down to a meal of fresh local seafood, remember those who fished the Outer Banks waters centuries ago: the native Algonquians, who used the bounty of coastal waters to help sustain them for thousands of years; the first English, who set out to explore and gather information to send back to the people of Europe; or those of the colonial period, who came to settle permanently in what explorer Ralph Lane called "the goodliest land under the cope of heaven."

YAUPON TEA

In the days when the Outer Banks were more isolated, its people were known for their hardiness and ability to improvise to meet their daily needs. Islanders planted gardens for produce and raised chickens and hogs for meat. Of course, fish was plentiful at certain times of the year, and shipwrecks could be used for lumber. As an alternative to coffee, Outer Bankers drank a tea made from the leaves and small twigs of the yaupon, a native shrub and member of the holly family.

Outer Bankers weren't the first to make yaupon tea. There are many accounts of Native Americans drinking yaupon tea for social and ceremonial purposes in the reports of early explorers in America. Explorer and surveyor John Lawson wrote in 1714, "This plant is the Indian Tea, us'd and approv'd by all the Savages on the Coast of Carolina, and from them sent to the Westward Indians and sold at a considerable price."

There are several steps in preparing the leaves and twigs (the berries of the yaupon are poisonous and never used), the first of which is curing.

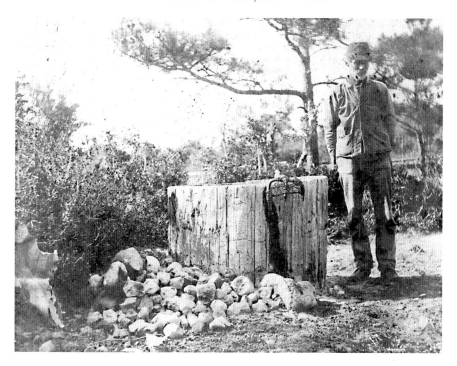

Preparing yaupon leaves for tea on Hatteras Island. Yaupon leaves and twigs were chopped fine and then layered in large barrels with heated ballast stones to dry the leaves, which were later used to brew tea. *H.H. Brimley Collection, State Archives of North Carolina, circa 1900.*

The Native American method involved bruising the leaves and twigs with a mortar and then placing them in a clay pot over a fire until the mix began to smoke. The next step in the process is drying the leaf/twig mixture completely, which the natives did by spreading it out on a mat and leaving it in the sun.

On Hatteras Island, the leaves and twigs were chopped fine by use of a hatchet. Large stones (often ballast rock from ships) were heated in a fire, and then the heated stones and chopped leaf/twig combination were layered in a barrel.

Accounts vary as to how yaupon received its Latin name, *Ilex vomitoria*. Native Americans used yaupon to make a purgative ceremonial beverage known as the black drink. Some historians attribute the purgative characteristic of the drink to the tea being made extra strong. Others believe that some other substance may have been added to the black

drink to cause vomiting, and yet others still think that the name refers to the poisonous nature of the berries.

Nags Head's Carolinian Hotel, which once symbolized the gracious hospitality of the post–World War II era, served yaupon tea to its guests and at special events. In the 1970s, Roanoke Island's Lynda Midgett volunteered to make yaupon tea for an open house at the Dare County Courthouse. Her husband's aunt, Martha Meekins Dough, known locally as Aunt Moth, oversaw the project. Midgett recalled, "I got two humongous pots from the diner, which was Doris Walker's Duchess of Dare, and I took them home and Aunt Moth showed me how to pull the leaves and dry the branches."

The leaves were dried in the sun until they got "brown and kind of crumbly." Midgett then placed the dry mixture in the borrowed pots, covered them with water and began to heat the concoction. All was going well, until she was overcome by the fumes. "I had both of these pots on the stove in the kitchen, and all of a sudden I started getting the worst headache I have ever had in all my life, and I'm sixty-eight and I've never had a headache like that since then."

Midgett said that the yaupon-induced headache put her to bed for three days. Her husband, Arvin, took over and moved the pots of the concentrated tea outside, where it cooled down and was later diluted. Aunt Moth later explained that the number of the leaves and the fact that it was so concentrated is most likely what brought about the malaise.

The event turned out a success, and the yaupon tea was a hit. "It was a wonderful day [in] downtown Manteo," Midgett recollected. "There were a lot of people there, and anybody who wanted a little taste had a taste. I did not indulge 'cause I'd already had my share of yaupon tea."

BRITISH OFF THE COAST: THE WAR OF 1812

Not thirty years had passed after the signing of the Treaty of Paris, which ended the American Revolution, when President James Madison called for Congress to declare war on Great Britain. In addition to the British encouraging Indians of the northwest American frontier to riot against

American settlers, their ships were commandeering American vessels and impressing American sailors—that is, they were forcing them to serve on British ships.

England was at war with Napoleonic France and refused to respect the rights of neutral nations. Consequently, war was declared on June 12, 1812, and over the next two years, there were numerous reports of the enemy off the North Carolina coast.

An account of the British near Currituck in December of 1812 was given by a William Healy, master of the sloop *Julian* of Washington, North Carolina, who wrote in a letter to the editor of the *Edenton Gazette*:

> *Sir—You will please to insert in your paper that there is at present off here three British Frigates doing all the harm they can. This morning they ran me on shore and took a large schooner, since then ran a brig on shore, and are now on the point of taking a schooner, all supposed to be coasters. They fired at me a great number of round and grape shot and when near enough, a constant fire of musquetry was kept up, but done no more damage with their shot than cutting a hole in the mainsail. Several balls fell on deck.*

In July 1813, British forces under the command of General Cockburn entered Ocracoke Inlet (North Carolina's busiest inlet at the time). There they captured two American vessels, the privateer brig *Anaconda* and the letter of marque schooner *Atlas*. A U.S. revenue cutter was also in the inlet but sailed quickly to New Bern without capture and brought the news to the people of that town that the enemy was entering North Carolina waters.

Thomas S. Singleton, collector of the customhouse on Portsmouth Island, wrote of the "wanton destruction of property" as an assortment of British regulars, marines and sailors landed at Ocracoke and Portsmouth villages. "They broke in pieces almost every species of furniture, cut open beds and even carried their villainy to such a length as to rob many women of their children's clothes without leaving them a second suit to their backs." It was reported that the invaders took two hundred head of cattle, four hundred sheep and 1,600 fowl, but some historians think that these numbers might be inflated.

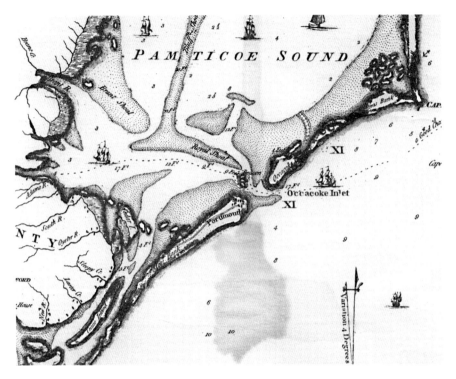

A portion of the Mouzon map of 1775 showing the villages of Portsmouth and Ocracoke. Both were raided by British troops during the War of 1812. *North Carolina Department of Archives and History reproduction at Dare County Public Library, Manteo Branch, 1966.*

Singleton was sent aboard a British ship while the raiders destroyed his office and library and "every paper in it, both public and private." It was fortunate that he had the foresight to send his trunk filled with the most valuable papers on the cutter that made it to New Bern, and he was also lucky to make it back to shore safely after the enemy put him adrift in a small boat, which floated over the bar, got into breakers and "vary narrowly escaped being lost."

Again in October 1814, nine barges carrying three hundred British entered Currituck Inlet and captured or burned vessels. John Mackie reported to the *Raleigh Register* that "[s]ome of their barges proceeded as far as the upper end of Churches Island others off Knotts Island, chasing oyster boats and canoes and firing on them."

During this raid, it was noted that Thomas Walker's house received a great many shots, causing his furniture to be destroyed. After returning

to the inlet, the troops killed fourteen or fifteen cattle and left the next morning. Mackie noted that while the British were in the Currituck Sound, there was "the greatest alarm and confusion prevailed."

The Treaty of Ghent, signed on December 24, 1814, brought about an end to the war and, consequently, raids on the coast by the British.

SCREW-PILE LIGHTS WERE ONCE A COMMON SIGHT ALONG THE RIVERS AND SOUNDS

Most people, when asked to describe a lighthouse, would tell of the magnificent towers that grace the coast, such as the Cape Hatteras, Bodie Island and Currituck Beach lighthouses. These spires stand more than 150 feet and signal seagoing mariners their positions offshore by beacons at night, as well as by their distinctive patterns by day.

Another type of lighthouse used to guide vessels in the shallow sounds and rivers of North Carolina was the screw-pile lighthouse. These smaller structures were built over five to fifteen feet of water on a base that rested on metal pilings that were actually screwed into the soft bottom of the sound or river. Original designs were six-sided, but they were later built with four sides and looked very much like a traditional house that would be built on land, with the exception of the light tower on top.

Screw-pile lighthouses were usually about one thousand square feet and equipped with fourth-order Fresnel lenses. These lenses, a collection of prisms and refractors, are classified on a scale of one to six. First-order lenses were the most powerful and were used in seacoast lights, while sixth-order lenses were used to mark rivers, harbors and piers. The screw-pile lights were also equipped with a bell that was used in times of low visibility.

The first screw-pile lighthouses were built in North Carolina in the years before the outbreak of the Civil War. Most were constructed to replace lightships, which had been established as aids to navigation in the 1820s and 1830s but could break free from their moorings during foul weather.

Antebellum screw-pile lighthouses in the area include the Roanoke Marshes Light, which marked the southern entrance to the Croatan

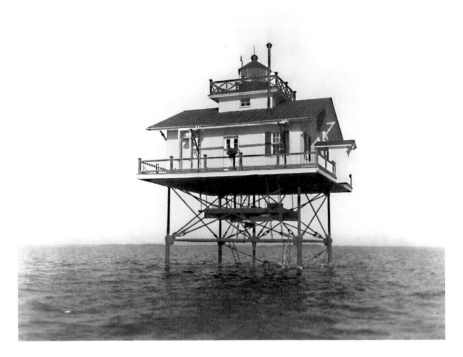

The Neuse River Light, which marked the entrance to the Neuse River in Pamlico County, was one of many screw-pile lights found along North Carolina's sounds. *U.S. Coast Guard, circa 1950.*

Sound just west of Wanchese, while the Croatan Light marked its northern entrance just east of Mashoes. Showing the western entrance to the Pasquotank River was the Wade's Point Light. Those built after the Civil War include the Oliver's Reef Light off Durant's Point on lower Hatteras Island and the Roanoke River and Laurel Point Lights constructed on the southern shore of the Albemarle Sound.

To say that life at these outposts was isolated is an understatement. Three keepers were assigned to each lighthouse, and they worked two men on/one man off. Access to and from the mainland was by boat, which hung over the water from the bottom of the lighthouse when not in use. In addition to serving as the home for the light keepers, it was also their office and place to store oil and wood.

United States Lighthouse Service regulations forbade a keeper's family from living at the lighthouse; however, this rule was sometimes broken. Those interested in learning more about what it was like to serve on a screw-

pile light will enjoy the account of the late Wayland Baum of Wanchese in *Lighthouse Families* by Bruce and Cheryl Shelton Roberts.

Some screw-piles fell victim to weather, while others were destroyed in the 1950s and replaced with beacon signals. Lighthouse enthusiasts have the opportunity to visit two replicas of screw-pile lighthouses. The Roanoke Marshes Light in downtown Manteo is a recreation of the light that stood west of Wanchese, and the town of Plymouth, North Carolina, in Washington County is home to a reproduction of the Roanoke River Light.

REACHING THE OUTER BANKS BY BOAT

Before the days of cars and bridges, the Outer Banks and Roanoke Island were much more isolated, and everything—people, food, clothing and supplies—was brought in by boat. Private vessels were used at first, but a number of steamers and freight boats began to make local stops at the turn of the last century.

Before the Civil War, Nags Head was a resort for the Albemarle region's gentry. Businessmen and planters sent their families to the coast to take in the salt air and swim in the ocean to escape the heat and threat of malaria inland. One of the first accounts of a steamer bound for the sand banks appeared in an 1841 advertisement for the Nags Head Hotel: "The Steamer *Shultz* will make a trip every Saturday from Franklin Depot, Va. to Nags Head, commencing July 12." After leaving Franklin Depot, the *Shultz* stopped for passengers along the Chowan River at Riddick's Wharf, Winton and Edenton.

The Nags Head Hotel Company owned its own steamer, *Clarence*, which ferried goods from Elizabeth City for the hotel and Nags Head's summer residents. A manifest from August 1892 reveals that the Hotel Company had dry goods, raisins, vegetables, groceries and meal shipped in, while grapes, watermelons, peaches, beer and whiskey were brought for the summer people.

Between the time it was named the county seat of Dare in 1870 and its incorporation in 1899, Manteo had become a growing water town.

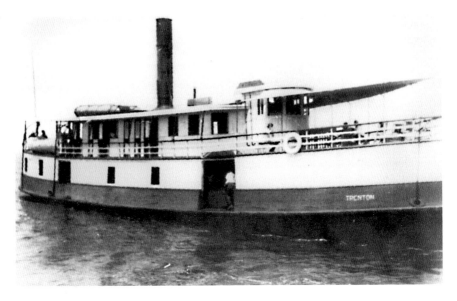

The steamer *Trenton* was a familiar sight in Manteo. The vessel made a daily trip to Elizabeth City and back. *National Park Service, Outer Banks Group, circa 1920.*

Two well-known vessels docked at the town waterfront, the *Trenton* and the *Hattie Creef*. Local boat builder George Washington Creef Jr. built the *Hattie Creef*, which he named for his daughter. The sailing vessel (originally a shad boat) was later fitted with an engine and was a common sight plying the waters of the Albemarle Sound on its daily route between Roanoke Island and Elizabeth City, carrying the mail, freight and passengers. The Wright brothers even traveled on the *Hattie Creef*, but this was on one of their subsequent journeys to the area in 1911, eight years after their famous first flight at Kitty Hawk.

During his fifty-year career, Captain Martin Johnson captained many vessels, including the *Hattie Creef* and the *Trenton*, and for many years, he was the sole proprietor of the mail service between Manteo and Elizabeth City. The *Trenton* left Manteo at 6:00 a.m., made a quick stop across the Roanoke Sound at Nags Head and then departed for Elizabeth City, where it would begin its return trip.

Edna Evans Bell described the vessel in her memoir, "My Birthplace and My Home," as

very big and elaborate to the Islanders because it was such an improvement on the old Hattie Creef. A young native of the island, Martin Johnson, was hired to pilot it. The time of travel between Elizabeth City and Manteo was five hours. The steamer would get into Manteo at 6 p.m. When it rounded the curve into Shallow Bag Bay, which had been dredged to accommodate it, Captain Johnson would start long blasts on the steam whistle and by the time he got to the dock, all the young people in town would be there to meet him and see what he had brought in.

The *Annie L. Vansciver* worked the North River Line between the North and Alligator Rivers, but on Sundays, it worked as an excursion boat, bringing day-trippers to Nags Head from Elizabeth City. Passengers would disembark at the docks on the sound side and cross the island to spend a day at the beach.

Skyco, on the west side of Roanoke Island, was also a docking point. The *Newberne* and the *Shenandoah* were propeller steamers that worked the Old Dominion Steamship run between Elizabeth City and New Bern, with a stop at Skyco. In 1890, a new steamer, *Neuse*, made the trip three times a week.

Construction of the Wright Memorial Bridge began in 1929, and by the early 1930s, automobile travel had led to the decline of the steamers, ending another colorful chapter of Outer Banks history.

AWASH AT HATTERAS: THE BURNSIDE EXPEDITION

Early in the Civil War, the Union set its eyes on Roanoke Island, knowing that it provided an excellent location for controlling Southern access to Norfolk and reducing the flow of supplies to North Carolina's inland port cities such as Edenton, Plymouth and Washington.

General Ambrose Burnside commanded an expedition to take Roanoke Island. It was divided into three brigades, led by Generals Foster, Reno and Parke, who were Burnside's "trusted friends" and former classmates from the U.S. Military Academy at West Point, New York.

The men who made up the Burnside Expedition (just fewer than five hundred officers and more than eleven thousand men) assembled at the U.S. Naval Academy at Annapolis, Maryland, and departed on January 9, 1862. After a brief stop at Fort Monroe near the mouth of the Chesapeake Bay, the ships of the expedition headed for the open sea on January 11.

The plan was for the fleet of more than eighty vessels (a collection of ferries, transports, steamers, gunboats, tugs and barges), loaded with men, horses, ordinance and supplies, to leave Fort Monroe, sail down the coast of Virginia and North Carolina and enter Hatteras Inlet. Two forts near the southern tip of Hatteras Island were under Union control after having been seized in late August 1861 by forces under command of Benjamin Butler. However, soon after rounding Cape Henry and entering the open ocean, the fleet met with foul weather and high seas.

William H. Chenery's recollections as a Rhode Island artillery soldier during the Burnside Expedition were published in 1905. His memories of the fate of his shipmates were poignant:

> [W]e began to feel the heavy swell of the ocean, and it was not long before some of our comrades began to experience what it was to be seasick. Several of them stepped or rather rolled to the rail and paid tribute to Old-Neptune. I was inclined to hope that I might be spared that affliction. But it was not so to be. I was sitting on top of the cook's galley, making sport of my sick comrades, when a nauseous sensation began to creep over me, and suddenly without any warning, I deposited the remnants of my dinner on the head of a comrade on the deck below.

Many of the ships had arrived at Hatteras Inlet by January 13, but high seas and strong currents made crossing the bar and entering the sound a precarious venture. The steamer *City of New York* unsuccessfully attempted to make the passage.

David L. Day of the Twenty-fifth Massachusetts Volunteer Infantry kept a diary of his participation in the expedition and reported the scene as it unfolded on the fourteenth. "This morning presents a scene of terror and wildest grandeur. The wrecked steamer has not broken up, but has settled down in the sand, the sea breaking over her, and her rigging is full

of men. Boats that have been sent to her assistance are returning, having been unable to render any." Although the vessel's load of ordnance was lost, its crew was eventually saved.

By the nineteenth, however, Day and the other soldiers had grown bored with their situation. "Witnessing boat collisions and wrecks is getting old, and the boys are amusing themselves by writing letters, making up their diaries, playing cards, reading old magazines and newspapers which they have read half a dozen times before; and some of them are actually reading their Bibles. Of all the lonely, God-forsaken looking places I ever saw this Hatteras Island takes the premium."

Seasickness was not the only unpleasantness among the men. An outbreak of measles was reported, as well as lice. Because the vessels were delayed in landing, and since it was dangerous for supply boats to approach other vessels for fear of collision, provisions throughout the fleet began to dwindle.

Chenery wrote, "While waiting here, our rations became scarce, and we were limited to three crackers a day and a small ration of salt beef.

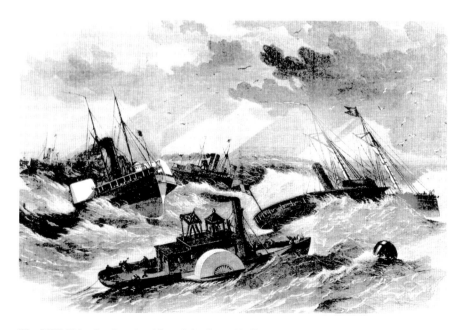

The USS *Picket*, leading the ships of the Burnside Expedition over the bar at Hatteras. *From the* Illustrated London News, *State Archives of North Carolina, 1862.*

This was not a very encouraging state of affairs for men who were just recovering from seasickness."

Most of the vessels had to be "lightened," which meant that cargo was unloaded, and this caused them to float higher in the water and created the need for less of a draught. Some had to be hauled over the bar by use of tugs. The weather finally broke, and the sea on February 3 was described as "calm as an honest man's conscience."

Additional losses suffered at Hatteras Inlet include the wreck of the steamer *Pocahontas* with a load of nearly one hundred horses, twenty-five of which were saved. Three men perished when the small ship's boat in which they were riding was dashed by high waves and capsized. They were the second mate from the ship *Anne E. Thompson* and Colonel J.W. Allen and Surgeon Weller of the Ninth New Jersey Regiment.

By February 4, the remainder of the fleet had made it through the inlet and the following day departed for Roanoke Island. On February 7, a naval battle ensued in the waters of the Croatan Sound. The Union forces bombarded Fort Bartow, halfway up the northwestern side of Roanoke Island. The Confederate navy attempted to defend the island with the sparse Mosquito Fleet made up of a handful of vessels.

That afternoon, between eight and ten thousand troops landed at Ashby's Harbor, midway on the west side of Roanoke Island. There the Federal troops bivouacked for the night and the next day advanced to the Confederate battle line near today's midway intersection. The Union forces, which greatly outnumbered their Southern opponents, charged, and the retreating Confederates were captured at the north end of the island.

Burnside and his troops later took New Bern, leaving northeastern North Carolina under Union occupation for the duration of the war.

THE LOSS OF THE *ORIENTAL*

It protrudes from the ocean—a great rusty barrel—one of the few landmarks along the desolate stretches of the Pea Island beach. Locals know the popular fishing and surfing spot as "the boiler," but Kevin Duffus, author of *Shipwrecks of the Outer Banks: An Illustrated Guide*, wrote that this

is a common misconception. The impressive piece of metal is instead a large steam cylinder from the shipwrecked sailing steamer *Oriental.*

Built in Philadelphia in 1861, it was pressed into Federal transport duty during the Civil War. Measuring 218 feet long and 34 feet wide, it could hold up to one hundred passengers. Its first voyage in service to the army was to carry the Forty-seventh Pennsylvania Regiment to Key West, Florida.

The *Oriental's* second mission was to transport mail to Union soldiers and to carry missionaries and antislavery workers to care for recently freed slaves. However, the ship ran into a violent storm and sank off the coast in May 1862.

Frank Leslie's Illustrated Newspaper of July 5, 1862, reported that "[t]he *Oriental* transport with General Saxon and suite sailed from New York to Port Royal 15th May and had proceeded as far as the coast of North Carolina when a storm arose on Friday night May 16th which drove the vessel on Body's Island, a sandspit 33 miles north of Cape Hatteras, abreast of Nag's Head, famous for being the place where Gov. Wise was sick at the Battle of Roanoke. The passengers and crew were saved; a great number of the cargo lost, while some was landed on the beach."

A sketch of the steamer *Oriental.* The remains of the ship can be seen off the beach at the Pea Island National Wildlife Refuge. *A.R. Waud, Morgan Collection of Civil War Drawings, Library of Congress, circa 1861.*

The Pamlico County town of Oriental, North Carolina's sailing capital, was named for the ship. Local history sources report that Louis Midyette, a farmer and fisherman from Stumpy Point, encountered a storm while sailing from New Bern. In order to ride out the foul weather, he anchored in Smith Creek, a tributary of the Neuse River. Midyette liked the look and layout of the area, and in about 1870, he moved there with his wife, Rebecca, and their family. Easier access to the Pamlico Sound's rich fishing grounds and the fish market at New Bern more than likely had something to do with his decision.

Robert Midyette, Louis's brother-in-law, also took up residence nearby. People from Dare, Tyrrell and Hyde Counties soon followed, and the settlement grew. There was not, however, a name for the post office. Rebecca Midyette suggested the name Oriental after finding the ship's nameplate. There are conflicting accounts as to whether she found it or simply saw the relic. It was formalized by the state in 1896 as a post office, and the town was incorporated in 1899.

Artifacts from the *Oriental* can be seen at the Oriental History Museum, open Friday, Saturday and Sunday afternoons. Look at a map before you go, as the sailing town is not really on the way to anything. It's a destination all its own.

Windmills Once Dotted the Coast

You see them spinning on Jennette's Pier, at Jockey's Ridge State Park in Nags Head and at the Brewing Station restaurant in Kill Devil Hills. Wind turbines are becoming part of the landscape of the Outer Banks as alternative energy sources are harnessed and renewable or "green" sources of power are used to reduce dependence on fossil fuels. Wind power is nothing new to Carolina's coast, where there is usually an ample supply of breezes combined with low-lying terrain. Between the mid-1700s and the early 1900s, numerous windmills used the wind-driven power to grind corn or pump water.

Most of what we know about these windmills comes from the research of Tucker R. Littleton, who spent a year poring over old deeds, maps,

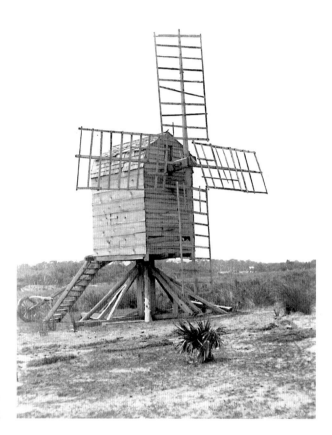

Windmills were once a common sight in coastal regions of North Carolina. Two dozen windmills were documented in Dare County by the late historian Tucker Littleton. *H.H. Brimley Collection, State Archives of North Carolina, circa 1900.*

books, legislation and photographs to shed as much light as possible on the wind-driven machines. He documented more than 150 windmills along the North Carolina coast, and while the bulk of them were located in Carteret County (65 documented structures), Hyde and Dare Counties were home to 24 and 21, respectively. It should be noted that these numbers represent the total number of windmills in existence, and they were not all in operation at one time.

During the Civil War, the structures were popular subjects for artist/soldiers who were stationed along the Tar Heel coast. Union soldier Charles F. Johnson with the Ninth New York sketched the area and kept a journal of his experiences. He remarked, "These windmills, by the way, are about the only things picturesque on the Island, and as objects of study for an amateur artist, they are admirable. I have sketches of them

all, I believe from here to Chicomocomico [*sic*], taken from all possible points of view, for they are all built after one plan."

The windmills were mainly of the variety known as the post mill. A tall, slender building was placed on a rotating base. A ladder was used to access the building, and a large pole was used to rotate the blades of the windmill (cloth stretched over wooden frames) to face whichever direction that would harness the wind. The rotating blades turned wooden gears that spun round, flat disks, known as millstones, between which the corn or wheat was ground.

Ironically, the decline of the use of windmills along the Tar Heel coast can be traced to the Great Atlantic Hurricane of 1899 and other storms. Heavy winds damaged many of the windmills, which were never rebuilt, especially with the advent of electricity and gas-powered engines.

After a visit to Hatteras Island, H.H. Brimley wrote in 1905, "A few old windmills still exist in the region of the Cape. The only one at Buxton went down in a blow last October and the only one still in active service is a few miles up the beach at Kinnakeet." A replica of a post mill windmill could be seen for many years in Nags Head at the Windmill Point Restaurant. It was disassembled and moved to Roanoke Island, where it is on display at Island Farm.

THE FORMATION OF DARE COUNTY

Although its namesake, Virginia Dare, was born in 1587, it took almost three hundred years for Dare County to come into existence. Merchant Joseph William Etheridge of Currituck County introduced the bill for the formation of Dare County in the 1869–70 session of the North Carolina General Assembly while serving in the North Carolina Senate. An amended act to lay off and establish Dare County was introduced and passed in 1873.

In order to create the new political subdivision, portions of land were taken from older counties established during the colonial period—Currituck in 1670, Hyde in 1712 and Tyrrell in 1729. From Currituck County came Roanoke Island and Nags Head. The Tyrrell County portion consisted

of the mainland area bordered by the Alligator River, Albemarle Sound, Croatan Sound and the Hyde County line to the south. Hatteras Island in 1869 was part of Hyde County.

It is interesting to note that until 1770, the southern portion of Hatteras Island and Ocracoke Island were not included in any county, "by which means the inhabitants thereof are not liable to pay taxes or perform any public duties whatsoever." This was remedied by placing the

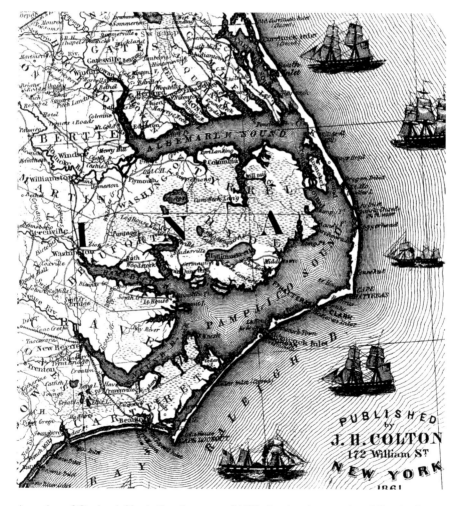

A portion of Coulton's North Carolina map of 1861 showing the counties of Currituck, Tyrrell and Hyde nine years before the formation of Dare County. *North Carolina Department of Archives and History reproduction at Dare County Public Library, Manteo Branch, 1966.*

area in Carteret County, but in 1823, Hyde received all the land south of New Inlet (south of present-day Oregon Inlet) from Currituck County and in 1845 received Ocracoke back from Carteret County.

The new county of Dare had a population of less than 3,500 residents, was composed of 388 square miles and divided into five townships for taxation purposes: Croatan Township and East Lake Township on the mainland, Hatteras Township and Kinnakeet Township on Hatteras Island and Nags Head Township, which encompassed Roanoke Island, Colington Island and the beaches from the Currituck County line (which at that time was just south of Kitty Hawk) south to Oregon Inlet.

A settlement on the harbor of Shallowbag Bay on Roanoke Island was chosen as the county seat of newly formed Dare County. In 1873, a courthouse was constructed, and the area was named Manteo by the United States Post Office. Manteo later became an incorporated town in 1899.

In 1930, Dare's boundaries were again changed when the beach area south of Caffey's Inlet was annexed to include Duck and Kitty Hawk. The new township of Atlantic was created from this new territory combined with Colington Island, and the area that is today Kill Devil Hills.

A memorial to Joseph William Etheridge is in the North Carolina Room at the Manteo branch of the East Albemarle Regional Library, which was funded by his granddaughter, Mathilde Etheridge Eiker, and great-nephew, William R. Etheridge, in 1973.

DIAMONDBACK TERRAPINS DECLINE WITH EACH BOWL OF TURTLE SOUP

During the late 1800s and into the twentieth century, the diamondback terrapin, found along the coast from Massachusetts to Texas, was a hot commodity, caught and sold as the chief ingredient of terrapin soup. The species has the distinction of being the best-tasting turtle in the world, and the dish became so popular that the once overabundant species was near the brink of extinction in North Carolina. Prices were driven from $3 per dozen to more than $100 per dozen for larger-sized turtles.

At one time, their numbers were so great that they could be considered an annoyance. It was said that fishermen in the vicinity of Stumpy Point Bay would sometimes lose a catch of fish because so many terrapins were in their nets that it was impossible to haul.

Records show that in 1897 Dare County yielded 6,251 pounds of diamondback terrapin with a value of $1,185, and in 1902, it led the state with 7,472 pounds at a value of $4,140. They were shipped from Manteo and Stumpy Point, as well as Wilmington, New Bern, Washington and Belhaven, with terrapins from the northern and central portions of the state commanding a higher price than those from the southern counties.

It was reported, "Some of the most highly valued terrapins in the state are found about Hyde County and neighboring shores." While no fishery records for diamondback terrapins exist for Hyde County, it can be surmised that many Hyde County reptiles were being caught by fishermen from Dare.

In 1906, the North Carolina Geological Survey published a report on the diamondback terrapin. Its letter of transmittal to the governor tells of the concern for the creature's survival. "On account of the rapid

Diamondback terrapins in Brunswick County, North Carolina. The reptiles were harvested in Dare and other coastal counties and were an important export at the turn of last century. *State Archives of North Carolina, circa 1890s.*

decrease in the quantity of the diamond back terrapin in eastern North Carolina waters, a report has been prepared by Dr. R.E. Coker on the habits, economic value, and cultivation of the diamond back terrapin, with suggestions regarding the prevention of its extermination."

In order to help the terrapin maintain its population, laws were passed restricting its collection between April 15 and August 15, and a five-inch minimum size limit was set. The 1906 report states that these laws were seldom enforced and that the closed season should be extended to March 1 to August 31.

Fortunately, two occurrences led to the decline of the diamondback terrapin's popularity. Prohibition helped terrapin soup fall out of fashion, as the dish was traditionally prepared with wine, and after the stock market crash of 1929 and the Great Depression, high-priced turtle meat was an extravagance that few could afford. By 1945, only 2,700 pounds of diamondback terrapin were harvested in North Carolina.

Although stocks are increasing, the diamondback terrapin will probably never rebound to its original numbers. They are still threatened by automobiles and loss of habitat or caught in crab pots and drowned; they also face a host of natural predators. A new threat is a market for the terrapin in China. This trend is driven by China's fondness for turtle soup coupled with the fact that many of their native turtles have been killed off.

Today, the diamondback terrapin is listed as a species of special concern in North Carolina. In March 2006, the North Carolina Wildlife Resources Commission banned the commercial taking of any native turtle species.

A STORM LIKE NO OTHER: THE GREAT HURRICANE OF AUGUST 1899

The hurricane of August 1899 was a tempest that spun for more than a month. After forming in the tropical Atlantic on August 3, it roared over Puerto Rico five days later on the feast day of St. Ciriaco, killing more than three thousand people.

On August 17, the storm laid waste to the Carolina coast. Diamond City, a barrier island town near the Cape Lookout Lighthouse on

Shackleford Banks, faced the full wrath of the storm. The tide rushed in from the sound, but as the storm moved north, the wind shifted and the island was inundated with ocean water. On Ocracoke, three anchored ships lost their mooring and floated out to sea. Homes and churches were damaged or destroyed altogether.

Much of what is known about the hurricane comes from the report of S.L. Doshoz, who was stationed at the Weather Bureau at Cape Hatteras. His research is impressive and valuable. "This hurricane was, without any question, the most severe of any storm that has ever passed over this section within the memory of any person now living, and there are people here who can remember back for a period of over 75 years. I have made a careful inquiry among the old inhabitants here, and they all agree, with one accord, that no storm like this has ever visited the island."

Doshoz also left a poignant account of the anxiety suffered by the Hatteras Islanders: "The frightened people were grouped sometimes 40 or 50 in one house, and at times one house would have to be abandoned and they would all have to wade almost beyond their depth in order to reach another. All day this gale, tide and sea continued with a fury and persistent energy that knew no abatement, and the strain on the minds of everyone was something so frightful and dejecting that it cannot be expressed."

After the hurricane passed, Doshoz noted that "strong men, who had held up a brave heart against the terrible strain of the past 12 hours, broke down and wept like children upon their minds being relieved of the excessive tension to which it had been subjected all through the day."

In Nags Head, winds were measured at eighty-five miles per hour at the Nags Head Lifesaving Station until the anemometer blew away. The ocean and sound met, leaving the tops of sand dunes protruding from the roily mess. Some made it to higher ground, wading through water four feet deep, while others were rescued by boat.

At 3:00 a.m. on the morning of August 18, Rasmus Midgett, a lifesaver at the Gull Shoal Lifesaving Station, was patrolling the beach on his banker pony. He knew a wreck was probable as he came upon the telltale sign of broken barrels and boxes washed up on the shore. He then heard the cries of the distressed mariners on the remains of the *Priscilla*.

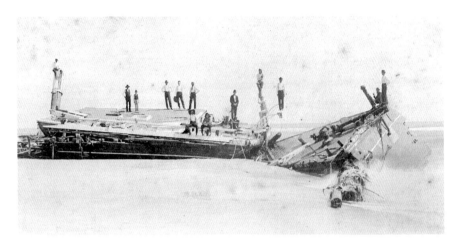

The remains of the barkentine *Pricilla*. Rasmus Midgett saved ten men from the ill-fated ship during the Great Hurricane of August 1899. *H.H. Brimley, State Archives of North Carolina, 1899.*

The hull of the barkentine had already broken in two and was grounded about twenty-five feet from shore.

Being miles from the station, Midgett knew that there was no time to summon help. He got as close as he could to the wreckage of the *Priscilla* and shouted instructions for the men to prepare to individually abandon ship. With great care, Midgett timed the waves and, taking advantage of the ebb, rushed closer to the ship and gave the command to jump.

Rasmus Midgett rescued seven men in this fashion, grabbing hold of them as they came overboard and carrying them to shore. Three men remained onboard, too weak to save themselves, so Midgett made another three trips into the surf and physically pulled each man off the remains of the vessel and then to shore. He was later awarded the Gold Lifesaving Medal for his heroism and bravery.

The emotional toll of the August 1899 hurricane was so great that it initiated an exodus of bankers from the barrier islands to places less vulnerable. Those at Diamond City moved (some even disassembled and barged their homes) to Marshallberg, Harkers Island or to a section of Morehead City that would become known as Promised Land. Down in Carteret County, the story is retold of the bankers leaving the island with their belongings on a barge singing the hymn "I Am Bound for the Promised Land." Several Hatteras Island families moved to Manteo to begin new lives in town.

MARKET GUNNING PUT FOWL ON NORTHERN TABLES

With the closing of Currituck Inlet in 1828, the Currituck Sound gradually changed from salt water to fresh water. New submerged aquatic vegetation developed, and the area became a prime habitat for migrating waterfowl. On a visit to Currituck in 1884, H.H. Brimley (who would later become curator of the North Carolina State Museum) estimated that there were as many as ten thousand Canada geese on the sound.

During the late 1800s, in addition to wealthy northern industrialists who ventured to the region to hunt waterfowl from land owned by private hunting clubs, market gunners also sought canvasback, redheads, mallards, black ducks, widgeons and teal, as well as geese and swan. Market gunners hunted waterfowl commercially. Ducks and geese were packed in barrels and sent to wholesale markets in New York, Washington, Baltimore and Philadelphia.

Alexander Hunter wrote of hunting practices in a March 1892 article in *Harper's Weekly*. "There are by law only two ways of killing ducks and geese at Currituck—by blind and by sink box. All big guns, sneak boats, and rifle-shooting are illegal."

Although illegal, a popular practice of the market gunner was to hunt ducks at night, otherwise known as "firelighting." Using a boat with a lantern and a gun mounted on the bow, market hunters could sneak up on a raft of sleeping ducks resting on the water's surface and kill dozens of them with a single shot. It was said that almost anything was used as shot, including pieces of chain link fence and carpet tacks.

Hunter's article admonished the hunting methods of the region:

The slaughter of wild-fowl a few years ago by every conceivable mode of killing became so barbarous that the Legislature passed stringent laws for protection of the water-fowl in Currituck; but they are evaded by unscrupulous pot-hunters and short-sighted natives, who kill ducks in the night time, and use swivels that slay whole flocks. It is a matter of serious complaint with the better class of sand dwellers and club men that these soulless pirates have materially reduced the shooting and there by injured this section.

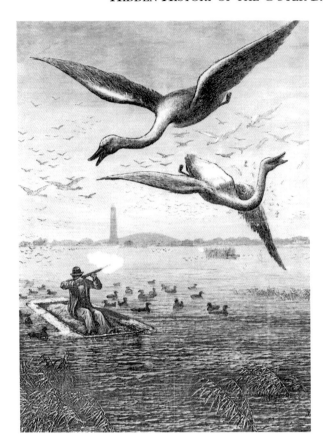

Shooting swans from a sinkbox in Currituck Sound. *From* Frank Leslie's Illustrated Newspaper, *State Archives of North Carolina, 1878.*

In his 1913 book *Our Vanishing Wildlife*, early conservationist and curator of the New York Zoological Park William T. Hornaday wrote of the great numbers of birds that had been taken. "Currituck County, N.C., was a vast slaughter-pen for wild fowl. No power or persuasion had availed to induce the people of North Carolina to check, or regulate, or in any manner mitigate that slaughter of geese, ducks and swans. It was estimated that two hundred thousand wild fowl were annually slaughtered there."

In the early part of the twentieth century, several state and federal laws were enacted to ensure the protection and proliferation of migratory waterfowl. The federal Lacey Act, passed in 1900, forbade the selling and transport of birds killed by illegal means. Market gunning was eventually outlawed in 1918 with the passage of the Migratory Bird Treaty Act, which banned the trade of birds, eggs and feathers.

Part II

STABILIZING THE SAND, 1900–1944

VIRGINIA DARE DAY

August 18 bears special significance in Dare County, as it is the birth date of its namesake—Virginia Dare—who in 1587 was the first child born to English parents in America. Town offices in Manteo close in recognition, and observances are held at Fort Raleigh and Elizabethan Gardens, while *The Lost Colony* drama uses live babies to play the part of infant Virginia Dare.

The first Virginia Dare Day assemblage took place in 1894, when the newly formed Roanoke Colony Memorial Association held its inaugural meeting. The organization formed for the "purpose of reclaiming, preserving, and adorning Old Fort Raleigh, built in 1585 by the first English settlers on Roanoke Island, the birthplace of Virginia Dare, the first white child born in America; and also to erect monuments and suitable memorials to commemorate these and other historical events in North Carolina."

The association purchased 250 acres of land on Roanoke Island's north end from the Dough family, including an additional 10-acre parcel that was the old Fort Raleigh site. Bylaws required that the annual meeting of stockholders be held on August 18 at the site of Fort Raleigh and that an annual inspection of the grounds be performed. Locals participated in the remembrances and provided picnic fare for the meetings, which helped the affairs grow in popularity.

The 1910 celebration was commemorated with a speech, "The Baptism of Virginia Dare," delivered by the bishop of the Diocese of North Carolina, the Right Reverend Joseph Blount Cheshire, and in 1911, the festivities (marred by a heavy downpour) included a paper presented by R.D.W. Connor, secretary of the North Carolina Historical Commission, "Sir Walter Raleigh and His Associates."

There is no record of events at Fort Raleigh in 1912, the 325th anniversary of Virginia Dare's birth, but by 1913, a new pavilion adorned the site, a full program was planned and the governor was invited. Speeches, a prayer and a rendition of "My Country, 'Tis of Thee" sung by a small chorus were all part of the production.

According to Professor William Powell in *Paradise Preserved*, "More than a thousand people gathered on August 18, 1923 for a day of speeches and for an elaborate picnic dinner. As on other occasions, the food was supplied by residents of the island and other nearby places. Dozens of boats from the communities of Dare County anchored in Roanoke Sound opposite the old fort." University of North Carolina professor Collier Cobb was one of the day's speakers. The year 1923 was also the first that the memorializations expanded to include short dramatic scenes to commemorate the efforts of the colonists. By 1925, a full-scale pageant was being presented by Roanoke Island residents.

The 1926 celebration, the weeklong Dare County Homecoming, garnered the greatest crowd up to that time and received much attention. Members of Congress from North Carolina and Virginia attended, including North Carolina congressman Lindsey C. Warren. The U.S. Navy Band made the trip south from Norfolk to play. Sir Esme Howard, the British ambassador to the United States, was the keynote speaker for the occasion.

Due to the lack of roads and bridges to Roanoke Island, all attendees not living on the island arrived by boat. Ben Dixon MacNeill covered the story for the *Raleigh News and Observer* and reported that "uncounted numbers" attended "from innumerable fishing villages along the coast." He commented, "These were the substance and the color of this unprecedented throng that came up from far places of the Sound in their little boats," and in the end, MacNeill proclaimed the day "the greatest for Dare County since the Raleigh Colony came through the inlet."

Virginia Dare Day commemorations were much easier to attend after the construction of the new Wright Memorial Bridge in 1930. Additional Dare County Homecomings were organized in 1931 and 1934, the latter date representing the 350th anniversary of the first Roanoke voyage of Amadas and Barlowe. That year, efforts were led by the Dare County Chamber of Commerce, and an Asheville company was hired to write and produce a professional show, *O, Brave New World: The Pageant of Roanoke*. The homecoming took place over a three-day period, August 17, 18 and 19, with a performance each night.

By 1937, the 350th anniversary of the birth of Virginia Dare, a new drama had debuted, Paul Green's *The Lost Colony*. On August 18, President Franklin D. Roosevelt attended the show. Except for a brief hiatus during

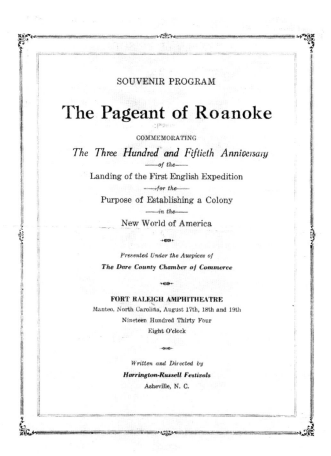

SOUVENIR PROGRAM

The Pageant of Roanoke

COMMEMORATING

The Three Hundred and Fiftieth Anniversary
——*of the*——
Landing of the First English Expedition
——*for the*——
Purpose of Establishing a Colony
——*in the*——
New World of America

Presented Under the Auspices of
The Dare County Chamber of Commerce

FORT RALEIGH AMPHITHEATRE
Manteo, North Carolina, August 17th, 18th and 19th
Nineteen Hundred Thirty Four
Eight O'clock

Written and Directed by
Harrington-Russell Festivals
Asheville, N. C.

Program for *The Pageant of Roanoke*, presented at the 1934 Dare Homecoming Celebration on August 17, 18 and 19. *David Miller, 1934.*

World War II, the play continued to entertain audiences and still does today. The use of several infants to play the part of Virginia Dare in various scenes has become an annual tradition.

THE *JAMES ADAMS FLOATING THEATER*: THE SHOWBOAT

In the early decades of the twentieth century, eastern North Carolina had few roads and fewer bridges. Most communities developed on waterways, and transportation was via boat. James Adams, former circus and carnival director and vaudeville man, came up with an ingenious way of bringing entertainment to these isolated communities. He built a theater on a barge, and for nearly thirty years, the *James Adams Floating Theater* made stops throughout the Albemarle and Pamlico Sound region and called upon communities along the Chesapeake Bay and its tributaries.

While showboats were commonplace on midwestern rivers by the late 1800s, it was Adams who had the idea to bring this type of craft to the East Coast. His vessel, which measured 128 feet long and 24 feet wide, was built in Washington, North Carolina, in 1919 and was pushed or towed from place to place by the use of smaller tugboats.

Adams first called his theater *Estelle* (and soon afterward, *Playhouse*). According to C. Richard Gillespie, who authored a book about the theater, Adams was informed by the Coast Guard that a vessel that large had to have its name identified on both port and starboard, so he had *James Adams Floating Theater* adorned on its sides.

It seated 500 people on the floor and an additional 350 in the balcony, which, due to segregated time in which the theater operated, was usually reserved for black patrons. The company, or troupe, consisted of a cast and a band. The cast had a repertoire of a half dozen or so plays along with vaudeville and specialty acts. Adams hired only married women whose husbands were also in the company.

The theater would usually stop in a locale for one week and perform a different play each evening, followed by a band concert. Manteo, Skyco, Columbia, Swan Quarter, Plymouth, Murfreesboro and Winton were some of the stops along the theater's itineraries over the years. The

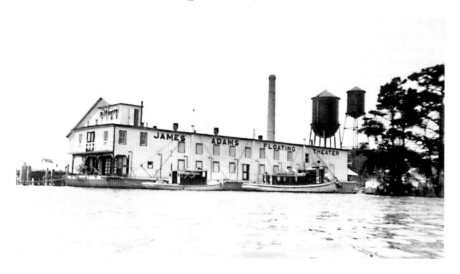

The *James Adams Floating Theater* during a stay in Edenton, North Carolina. The theater was towed to coastal towns along the Chesapeake Bay and the sounds of North Carolina. *State Archives of North Carolina, 1925.*

James Adams Floating Theater also played Elizabeth City and wintered-over there many years. Any work that needed to be done off-season could be taken care of in Elizabeth City for much less than it would cost in Baltimore or Philadelphia.

Pulitzer Prize–winning author Edna Ferber spent time with the *James Adams Floating Theater* in 1925 at Bath and Belhaven and used her experience to write the novel *Show Boat.* Ferber's work became the basis for the Broadway musical, which in turn became the basis for several films entitled *Show Boat.*

The theater barge was not without real-life drama. It sank more than once, the cast and crew experienced accidents and mishaps and fires broke out. Some communities were not showboat-friendly and denounced it and its performers as wicked and sinful.

Gillespie pointed to several contributing factors that affected the *James Adams Floating Theater.* Radio and movies were becoming popular, better roads and the construction of bridges led to ease of travel and the decline in the use of the steamboat caused steamboat wharves to fall into disrepair. Additionally, taxes in some states and towns made a visit by the theater unprofitable.

Adams sold his floating theater in 1933, but it continued on for another eight years under the name the *Original Show Boat*. In twenty-seven seasons, it traveled as far north as the New Jersey and to Florida in the South. Thousands viewed the shows and heard the concerts, and the theater became a pleasant memory for many coast residents. The *James Adams Floating Theater* is documented in the histories of many small coastal communities.

The Virginia Dare Shores Pavilion

This pavilion, on the shores of Kitty Hawk Bay, was built at the site of one of Dare County's first subdivisions, Virginia Dare Shores. The Carolina Development Corporation, spearheaded by illustrator turned land developer Frank Stick, held many large tracts of land "between the Currituck County line and Cape Hatteras, with both ocean and sound frontage." Stick visited the Outer Banks on a hunting and fishing trip in the mid-1920s and almost immediately recognized the area's potential as a resort destination due to its historical attractions, natural beauty and the recreational opportunities that miles of undeveloped beaches provided.

The Carolina Development Corporation acquired the Virginia Dare Shores tract of land and promoted the territory as having "great stretches of glistening sands, the music of never ceasing roaring roll of ocean, open spaces snuggled between woodland dells, reposeful ponds and silvery inland waterways, giant oaks, swaying sycamores, sentinel pines, and verdant fields, fluttering birdlife rich in colorful plumage, ocean and bays teeming with every luscious species of finny tribes, myriads of wild fowl, and the uplands generously supplied with big and small game."

The Virginia Dare Shores pavilion, which measured sixty by sixty feet and could hold three hundred people, was the site of part of the celebration held for the twenty-fifth anniversary of the Wright brothers' first flight in 1928. Influential men of the Albemarle area had been hard at work opening up the region and its historical and scenic attractions. The Dare County Homecoming Committee, working with the Roanoke Colony Memorial Association, orchestrated an elaborate homecoming

The Virginia Dare Shores pavilion on the shores of Kitty Hawk Bay was the landing point for many guests at the twenty-fifth-anniversary celebration of the Wrights' first flight and the laying of the cornerstone of the Kill Devil Hills National Memorial. The monument was later named the Wright Brothers National Memorial. *Outer Banks History Center Collections, circa 1928.*

on August 18, 1926 (known locally as Virginia Dare Day, as it was the birth date of the first white child born in America).

Another fête was held in July 1927, when the Chowan Bridge, connecting Chowan and Bertie Counties, was completed and dedicated. The structure was billed as the "longest highway bridge over freshwater on the Atlantic coast," as well as "a great engineering feat to reclaim the Albemarle district of North Carolina." Celebrants were again called to Dare County in December 1928 for the silver anniversary of the birth of aviation to witness the laying of the cornerstone of the future Wright monument. The Wright Memorial Bridge, the first span connecting the Outer Banks with the mainland, was complete in 1930, and the Wright Memorial was dedicated in 1932. These events show a dogged determination to make the Outer Banks and Albemarle region more accessible while showing off the area's assets to a larger audience.

Before being driven to the site of the birth of aviation at Kill Devil Hill, visiting dignitaries to the 1928 celebration were treated to a barbecue luncheon at the pavilion. Dudley Bagley of Moyock had arranged delivery of ten dressed pigs, while slaw, yams, potato salad and other

accoutrements were prepared by Penders restaurant in Norfolk. Rennie Williamson of Manteo chaired the Ladies Serving Committee. She was charged with selecting "not less than 25 of the best looking young women on Roanoke Island to be enlisted to report to Virginia Dare Shores Pavilion on the morning of December 17." Listed as "prospects who are usually glad to cooperate" were Mrs. Leo Midgett, Mrs. Mary Mann Evans, Mrs. E.E. Meekins, Mrs. Martha Dough, Mrs. Hazel Midgett, Mrs. Guy Lennon, Miss Harrell and Miss Viniarski. It was noted, "The appearance of these women who will serve naturally will be a great advertisement for Dare County."

The Ladies Serving Committee was to "have the responsibility of serving the distinguished visitors," which included Orville Wright, North Carolina governor Angus McLean and a delegation of the International Conference for Civil Aeronautics. W.O. Saunders, president of the Kill Devil Hills Memorial Association and editor of the Elizabeth City newspaper, the *Independent*, expected only the best in both hospitality and hog. He wrote to D. Victor Meekins, who was in charge of arranging Dare County's role in the event, "You might talk to the barbecue men at your place and see if they want the job and what they will want for their services. I would not expect them to work for nothing, my idea being to pay them well for a good job. If you don't think they are expert I don't want them."

The Carolina Development Corporation, in addition to building the Virginia Dare Shores pavilion, constructed at the site a similar building that was used as an office, as well as two cottages. Captain Dan Hayman, a local retired boat captain, held an interest in the property and acted as its unofficial caretaker since Stick and other shareholders lived out of state. In some sort of planning glitch (or power play), Hayman must have scheduled his own event in the pavilion, which drove Saunders to threaten to call off the anniversary celebration. He wrote to Frank Stick:

> *The fate of the Wright Memorial and every good interest of that coast section depends upon the proposed celebration. We cannot stage this celebration if we are not to be provided with every facility for the comfort and entertainment of our guests; and if Captain Hayman is to sacrifice the Wright Memorial project and the best interests of that coast section*

for the sake of making a splurge for himself and harvesting a few dollars from the sale of hotdogs, sandwiches and bum coffee, then I am done with the whole business. I trust that you will get on the job right away and let us get this thing straightened out so that I shall know exactly how to proceed. If Captain Hayman is going to gum the works I am off for life.

Stick had enough planning hurdles of his own trying to arrange decorations at the pavilion. "I wonder if anything has been done about decorating the pavilion…I have ordered 100 yards of bunting and three sets of flags of all nations…I believe nothing would give a more festive appearance in the decorating of the interior and exterior of the pavilion than the generous use of small pines, pine branches and holly, and my thought would be to use it around the interior of the building and on the rafters…The pine could be cut from the Kitty Hawk woods or on Colington Island."

All in all, the celebration was "nearly perfect." W.O. Saunders realized at the last minute that "without hotel facilities of any sort at Kitty Hawk and with nothing to wash in except Currituck Sound and the Atlantic Ocean, a fellow would appreciate a chance to clean up if it were no more than his fingertips," so fingerbowls were provided for the luncheon guests. Saunders also admitted that he was "momentarily peeved" when "half of the cars that carried the pilgrims to the Hills, deserted their guests there and made it necessary for a few cars to make trip after trip to take care of the situation." However, Saunders was a wise man, and instead of pointing fingers and assigning blame, he had praise for D. Victor Meekins, writing, "I have never for a moment lost sight of the loyalty and labor of you and your committees, and I would be the last person in the world to say anything publicly that might by a stretch of the most perverted imagination be taken as a reflection on the leadership of your great county."

The Virginia Dare Shores pavilion was destroyed by a severe coastal storm, probably the great hurricane of 1933, but Frank and Mattie Richlie of Kitty Hawk salvaged its lumber. They used the timber to build their small home in Kitty Hawk village, which is still standing today.

Kitty Hawk Residents Erected Their Own Memorial to the Wrights

One of the great attractions along the Outer Banks is the Wright Brothers National Memorial, which pays homage to Orville and Wilbur Wright, who in 1903 were the first men to fly in a heavier-than-air machine. The stunning sixty-foot granite monolith, authorized in 1927 and completed in 1932, stands atop of the stabilized Kill Devil Hill—a fitting tribute to these men.

However, the Wright Brothers National Memorial was not the first monument in Dare County erected to honor the Wright brothers. William Tate of Kitty Hawk, who corresponded with the Wrights before their arrival on the Outer Banks and acted as their unofficial host, had dreams to memorialize the inventors of flight.

Tate wrote to Orville Wright in 1927, "When the news reached me through the papers in 1912 that Wilber [*sic*] was dead, I at once began to tell my neighbors at Kitty Hawk that we should erect a memorial to his memory on the spot where he first began his labors in our midst. I received little if any encouragement." After federal legislation was enacted by Congress to create a national shrine to the Wrights at Kill Devil Hills, the idea of the Kitty Hawk monument took off.

According to Catherine Albertson in the booklet *Wings Over Kill Devil Hills and Legends of the Dunes of Dare*, "On September 23, 1927, a mass meeting was held at the public school building at Kitty Hawk. The meeting was addressed by Captain Tate, Rev. W.A. Betts, and others, and an organization was got together for the purpose of erecting a marker on the spot where Wilbur Wright did the first work of assembly of the 1900 machine."

Only those who lived in Kitty Hawk or were past residents were allowed to donate money for the cause, ensuring that it would remain a local effort. In 1928, Tate once again wrote to his friend Orville. "It is not an imposing monument. It did not cost a fabulous sum. But we are proud of the fact that we have seen fit to do this."

The small white marble obelisk marker was unveiled on May 2, 1928, in a ceremony that was described as simple and informal and attended by about five hundred people from Kitty Hawk and neighboring communities.

Elijah Baum shows off the memorial to the Wright brothers erected by the citizens of Kitty Hawk. This monument was dedicated six months before the national memorial at Kill Devil Hill. Baum greeted Wilbur Wright when he came ashore Kitty Hawk in 1900 and led the inventor to the home of Bill and Addie Tate. *State Archives of North Carolina, circa 1950.*

The inscription read, "On this spot September 15, 1900 Wilbur Wright began assembling the Wrights first experimental glider which led to man's conquest of the air. Erected by the citizens of Kitty Hawk, 1927."

W.A. Betts acted as master of ceremonies and gave a speech about the Wrights' early struggles on the Outer Banks. While many invited dignitaries were unable to attend, the event garnered attention in papers across the country and from the Associated Press. Newspapers in Fairbanks, Alaska; Oshkosh, Wisconsin; Hattiesburg, Mississippi; and Kokomo, Indiana (just to name a few), ran stories about the monument around the time of its dedication.

After sixty years, the old obelisk marker began to show signs of aging, and a duplicate marker was created and placed on the spot in 1987. The original marker is now on display in the Kitty Hawk Town Hall.

THE WRIGHT BROTHERS NATIONAL MEMORIAL: FROM CONCEPTION TO DEDICATION

The bold gray triangular obelisk, the Wright Brothers National Memorial, rises impressively from Kill Devil Hill, as if shouting to those who pass it, "You are here, the birthplace of aviation!" On that ground, two brothers from Ohio changed the world when on December 17, 1903, they flew for twelve seconds in a heavier-than-air craft. The eightieth anniversary of the dedication of the iconic landmark that pays tribute to the Wrights and their accomplishments was marked in 2012.

Hiram Bingham, senator from Connecticut and president of the National Aeronautic Association, introduced a bill in Congress on December 17, 1926, to create a monument to honor the events at Kill

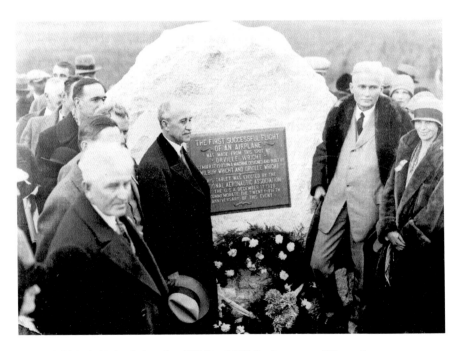

Orville Wright (with hat in hand) at Kill Devil Hill for the twenty-fifth-anniversary celebration of the Wright brothers' first flight. The laying of the cornerstone for the memorial took place during the festivities, as did the dedication of a monument that marked the start of the Wrights' historic flights. Next to Orville Wright is Senator Hiram Bingham, who introduced legislation requesting a monument be created to honor the Wrights. Next to Bingham is aviatrix Amelia Earhart. *State Archives of North Carolina, 1928.*

Devil Hills. On the same day, North Carolina congressman Lindsay C. Warren sponsored a similar bill in the House of Representatives. Bingham's resolution was passed and signed by President Calvin Coolidge on March 2, 1927. Later that year, the Kill Devil Hills Memorial Association formed with the purpose of creating a proper memorial to the achievement of flight.

The cornerstone of the Kill Devil Hills National Memorial was laid on December 17, 1928, at the twenty-fifth anniversary celebration of the first flight. Another marker, a large boulder with a plaque that marked the spot from which the Wrights began their flights, was dedicated the same day by the National Aeronautic Association. The 1928 event, organized by the Kill Devil Hills Memorial Association (later renamed the First Flight Society), was well attended, and other than a few glitches in transportation, it went off without a hitch.

A $20,000 federal appropriation was allotted to stabilize the hill. Captain John A. Gilman of the Quartermasters Corps of the U.S. Army was sent to survey the project. He brought in Captain William H. Kindervater, a construction engineer with the Quartermasters Corps, to oversee the stabilization of Kill Devil Hill and the construction of the monument. It was reported Kill Devil Hill migrated some 450 feet to the southwest between the Wrights' first flight and the commemoration of its twenty-fifth anniversary in 1928.

In order to control free-ranging livestock, eighty acres were enclosed by a fence to keep the hogs and cattle out. Grasses best suited for covering and stabilizing the sand hill were wire grass and bitter tannic. Later, native shrubs such as myrtle and yaupon were added to the landscape. Squash, watermelon, tomatoes and beans grew in an experimental tract on the site. Captain Gilman said, "Frankly, I had only hoped for success. I had no idea we would have this much to show just six months from the beginning."

Allen Heuth, Frank Stick and Charles Baker donated the land for the monument. The final transfer of the property took place September 1930, when Willis Briggs, assistant U.S. district attorney, visited Manteo and completed the paperwork for the 375-acre site.

The look of the proposed memorial was determined by a contest. Three dozen entries were received and judged. The New York firm of

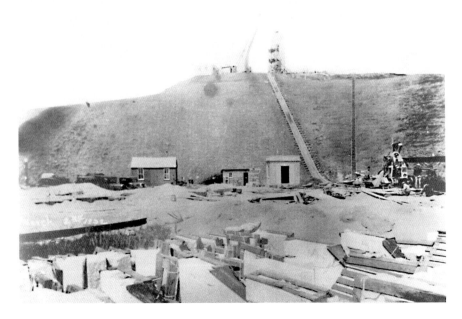

Construction of the Kill Devil Hills National Memorial, later renamed the Wright Brothers National Memorial. Before construction, the sand hill was stabilized with grasses and shrubs. *Fred Fearing Collection, Outer Banks History Center, 1932.*

Rogers and Poor created the winning design. The innovative concept of a granite pylon in the shape of a wing and a five-pointed-star base was a perfect tribute to the ingenuity of the Wright brothers. The plan reflected the Art Deco style popular at that time. The monument design included a lighted beacon to be used for both maritime and aviation navigation. The contractors chosen for the project, the Wills and Mafera Corporation of New York City, planned to begin work in February 1931, but a delay in delivery of the construction material caused the project to start at the end of the year.

The exterior of the monument is gray granite from Mount Airy, North Carolina, and the interior of the shaft features walls of pink granite from Salisbury, North Carolina, and a floor of black granite from Wisconsin. The impressive stainless steel doors that lead inside are adorned with eight bronze panels with raised sculptures that depict scenes of man's attempts to fly. Around the base of the monument is the inscription, "In commemoration of the conquest of the air by the brothers Wilbur and

Orville Wright conceived by genius and achieved by dauntless resolution and unconquerable faith."

Dedication of the monument, originally known as the Kill Devil Hills National Memorial, took place on Saturday, November 19, 1932. Heavy rains inundated the area the week before the event, and dedication day was marked by intervals of chilly rain and blustery wind. Newspaper accounts referred to the area as "the bleak coast." The flyovers and special aviation events were marred by the forecast, but a twenty-one-gun salute went off as planned. Speeches were interrupted by deluges of rain and the sound of flapping canvas when the top of the speakers pavilion was torn away in a particularly heavy gust.

Eminent guests on hand included North Carolina governor-elect J.C.B. Ehringhaus, Congressman Lindsay C. Warren, newspaper publisher Josephus Daniels, Virginia governor John G. Pollard and Orville Wright. Aviatrix and New York socialite Miss Ruth Nichols unveiled the monument, which Patrick J. Hurley, U.S. secretary of war, accepted on behalf of the nation. The final price tag for construction was $285,000.

In his remarks to the damp and windblown crowd, Hurley said, "As a direct result of their successful flight right here at Kill Devil Hills the conquest of the air is to be achieved. I used the future tense advisedly. Great as has been the progress since these intrepid men achieved the first successful flight in a power driven plane air transportation is yet in its infancy."

On November 21, 1932, an article ran in the *Elizabeth City Daily Advance* under the headline "Feeling of Resentment Seen in Dare County as Result of Wright Memorial Dedication" and put the blunders of the dedication under scrutiny. Blame was placed on the War Department for poor planning. A major criticism was the fact that parking near the monument was limited to a small group of VIP invitees, although the area would have easily accommodated hundreds of cars. The less fortunate were expected to park offsite and walk three quarters of a mile through the wet sand to attend.

It was reported that of the special invitations issued, only six residents of Dare County were included:

The failure of recognition of Dare County people as worthwhile folks by those who had charge of the selection of special guests will be a sore-spot for many years to come, according to comments heard Saturday night and yesterday. It is understood by them that every individual could not be a special guest, but for the mayor of the county seat to have been left out for the several business men here and at other places, not to have been included in the list along with the mayors of Edenton and Elizabeth City and business men of those towns is not understood.

Another faux pas was blamed on the State Highway Department. The torrential rains that took place in the days before the dedication caused great flooding along the Beach Road. A delegation from Manteo took an investigatory drive to survey the situation and wired the State Highway Department about the road conditions. On the day of the dedication, many cars traveling from Roanoke Island stalled out in standing water or were refused passage north. This accounts for why there were only hundreds and not thousands of people in attendance for the dedication.

The site of the monument, already a popular attraction, was transferred from the War Department to the National Park Service on August 20, 1933. It was renamed the Wright Brothers National Memorial in 1953, the golden anniversary of the first flight. The Visitor Center was completed in 1963 as part of the Park Service's Mission 66 initiative. In preparation for the centennial of flight, the monument underwent a renovation and was rededicated on May 2, 1998. The Wright Brothers National Memorial receives nearly 500,000 visitors annually.

THE CAROLINA BEACH PAVILION

Shortly after the completion of the Wright Memorial Bridge, which linked the mainland to Kitty Hawk at Point Harbor, a pavilion was built on the beach in the vicinity of today's Kitty Hawk Pier. This new amusement place first went by the name of Pirate's Den, but after a few years, a new phase for the pavilion began in 1932 when Chuck Collins,

president of the Kitty Hawk Amusement Company and football coach at the University of North Carolina, took over ownership.

According to a story in the *Independent*, Collins made several improvements to the property, upgrading the light plant, freshening up with paint and building a 325-foot boardwalk along the ocean. The new and improved attraction was described as "a high class dining and dancing pavilion, where good order would be maintained at all times by special police and where bathing would be made safe by experienced life guards." The headline called the building the Kitty Hawk Casino. Later, in the same article, it was tagged the Carolina Beach Pavilion. Either way, it promised to be "a high class resort free from hoodlumism and disorderliness." Keep in mind this was during prohibition.

Collins hired W.J. Cerney to manage the business for the 1932 season. Cerney, a backfield coach for the Tar Heel football team, was assisted by five Carolina football players, who served as bouncers and lifeguards. Bill Croom, described as a "powerful halfback," was made a special policeman by the Dare County Board of Commissioners and as such had the power to deputize the other athletes if needed.

The Wright Memorial Bridge Company made a special arrangement with Collins. Visitors to the pavilion received special pricing when traversing the span across the Currituck Sound—they only had to pay to cross the bridge, but the return trip was free.

By the Fourth of July, the Carolina Beach Pavilion and Sheik Alford's Sea Hawk Inn (the forerunner of the Nags Head Casino) were ready to welcome and entertain summer crowds for the 1932 summer season. Large advertisements touted the amenities of each club. However, trouble was brewing down south.

Collins advertised his club and the surrounding recreation area as Carolina Beach, and this didn't sit well with the New Hanover County town of the same name. Louis T. Moore, executive secretary of the Wilmington Chamber of Commerce, shared the information about the new northern "Carolina Beach" with the mayor and commissioners of the southern North Carolina town of Carolina Beach. The news caused an all-out up-in-arms protest. Although the town of Carolina Beach incorporated in 1925, the name was in use years earlier. A suit was

An advertisement from the *Elizabeth City Daily Advance* before the July 4, 1932 holiday, extolling the virtues of Carolina Beach at Kitty Hawk. The New Hanover County, North Carolina town of Carolina Beach protested over the use of the name. *Outer Banks History Center Collections, 1932.*

filed, and Judge N.A. Sinclair rendered a decision that the Kitty Hawk Amusement Company cease and desist using the name Carolina Beach. It was then dubbed Kitty Hawk Beach, a name frequently used today.

After Collins was unable to make payments to his creditors, W.T. Culpepper purchased the pavilion when it went up for sale at the Dare County Courthouse steps. In keeping with the football theme, George Hunsuker, coach of the Elizabeth City High School football team, was selected to manage the club, which was by then going by the name of Kitty Hawk Pavilion.

In December 1934, the Kitty Hawk Pavilion was consumed by fire in an early morning blaze. J.G. Twiford, tender of the Wright Memorial Bridge, spotted the flames and alerted authorities. Portions of the boardwalk were severed so that the flames did not spread to adjoining cottages. Revelers still had two club options—the Sea Hawk and the new Nags Head Beach Club, which opened for the 1934 summer season.

The CCC and WPA Built Sand Dunes
Along the Beaches

Dare County's beach towns are always touting their sandy strips as the chief draw for visitors. Nags Head underwent a $30 million nourishment project in 2011 that added millions of cubic feet of sand to its beaches. But nourishment and dune replacement are not new topics along the Outer Banks. Attempts to hold back the ocean stretch back to the 1930s.

A profound effect of the Great Depression that followed the stock market crash of October 1929 was mass unemployment across the country. Franklin D. Roosevelt was elected president in 1932 on a platform of a "New Deal" for America. Legislation passed early in his administration was designed to put the jobless back to work.

One of these New Deal programs was the Civilian Conservation Corps (CCC), made up of young men between the ages of eighteen and twenty-five, many of whom had never traveled far from home. Some had never left their own counties. They were housed in military-style camps and received uniforms and meals. They were also assigned work projects for which they were paid thirty dollars per month, most of which was sent home to the boy's family. CCC Camp Virginia Dare was established on Roanoke Island in November 1934.

The Transient Division of the Works Progress Administration was another program geared toward employing the masses. It administered grants to individual states for specific labor projects to employ transient workers. Between the spring of 1934 and 1935, six transient centers were set up across North Carolina. From these clearinghouses, men between the ages of eighteen and forty were sent to locations throughout the state to perform a variety of tasks.

"Kitty Hawk Transient Camps" in Nags Head was established in April 1934 with developer Frank Stick as its director. Men were housed in Parkerson's old pavilion, the same building that would later become a legendary dance and recreation hall, the Nags Head Casino.

One of the projects undertaken by both the CCC and the transient workers was sand fixation along the beaches. Plans were to establish protective dunes through the placement of fences made from "thinning

timber strands" and "clearing underbrush" and then to plant native grasses to stabilize the newly created dunes.

In a June 1934 newspaper article, Stick explained the future of the sand fixation project. "Twelve months from today, where now we see but sandy wastes, bare of grass and obstruction excepting for the meandering lines of fencing which our transients produced, will have sprung up grass-topped dunes."

A description of the process was published in the *High Tide*, the Camp Virginia Dare annual: "The single fence is not built in a precisely straight line, but rather tends to follow the contour of the shoreline. The prevailing winds strike the fence at an angle, thus intercepting the travel of thus and being carried on the same."

Perpendicular to the fence, brush fences forty feet high and thirty feet wide were installed to trap additional sand. "Since this acts as a barrier it causes the sand to remain on the fence and by so doing the efficiency remains practically constant. When the sand builds up to the top of the

WPA workers construct brush fences near the Creeds Hill Coast Guard Station on Hatteras Island. The fences collected blowing sand to create dunes. *National Park Service, Outer Banks Group, 1936.*

first fence then another fence is place atop the original and the sand continues to mount higher and higher. This procedure is repeated until the desired height and width is obtained."

The idea of a camp of transient workers didn't bode well with summer residents of Nags Head, and after a car was stolen by a camp worker, who used a false name when he enrolled in the transient program, a scathing report was published in an Elizabeth City newspaper pointing out that "[w]hile it is true there are many good men in the camp who want to get a new start in life, or who are really trying to work, the fact remains that the ranks are filled from the transient bureaus of the various cities, who recruit whoever may apply. No questions are asked. Many of them out of prison are looking for someplace to hide out temporarily."

After the transients received the bad press, another article soon followed with the headline, "Competent Witnesses Testify in Defense of the Men of Kitty Hawk Transient Camp," and three prominent people wrote of the other and brighter side of the situation and described the men with whom they had worked as descent, conscientious, courteous and obliging.

An influx of additional men in the fall of 1934, combined with the concerns expressed by the Nags Headers, caused another camp, Camp Weaver, to be created near Whalebone Junction, and the men of Camp Kitty Hawk were eventually transferred there.

Other work performed locally by the CCC and transient workers included improvements to Coast Guard property in Dare and Currituck Counties, restoration of the Fort Raleigh site, improving and repairing roads, painting schools, oyster propagation and cutting wood for helpless women.

FREE RIDES ACROSS THE ROANOKE SOUND BRIDGE

The geographic makeup of the Outer Banks makes traveling across bridges an everyday occurrence. Debates over building new spans and replacing old ones have been in the Outer Banks news recently as the Herbert C. Bonner Bridge across Oregon Inlet ages and deliberation continues over how long a bridge should replace it. To the north, lovers of

the Currituck Banks argue about whether a bridge connecting mainland Currituck with its beaches would enhance or detract from the area.

The first bridge in Dare County connected Roanoke Island with Nags Head and was the brainchild of Washington Baum. As chairman of the Dare County Board of Commissioners during the 1920s, he had an interest in seeing the county grow and prosper. Talk had begun of attracting visitors to the area's beaches and historic sites, but first they needed to be able to get here.

The Roanoke Sound Bridge was built and in operation by 1928 (to save money, the swing span portion of the bridge was taken from an old bridge in Buffalo City, the late nineteenth-century logging town on the mainland), financed in part by the issuance of county bonds. A toll was collected to help repay the bonds. There are conflicting accounts on the amount of the toll, one being twenty-five cents per person each way and the other one dollar per car. Coupon booklets that cut the price in half were for sale.

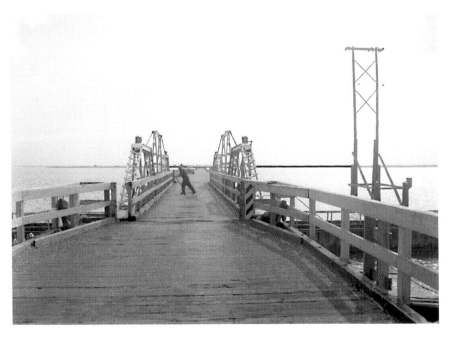

The Roanoke Sound Bridge connecting Roanoke Island and Nags Head was completed in 1928. During the 1930s, tolls were unfairly waived. *North Carolina Department of Conservation and Development, Travel Information Division, State Archives of North Carolina, September 1949.*

However, by 1935, the county was losing potential revenue due to the fact that free passes had been issued to many drivers who frequently used the bridge. This included lighthouse attendants, keepers and crewmen of the U.S. Coast Guard stations, the caretaker of the Wright Brothers Memorial and men using government trucks involved in forestry work with the Civilian Conservation Corps and WPA transient camps. It was said that keepers of the hunt clubs that encompassed large tracts of land south of the Roanoke Sound Bridge also traversed the structure at no charge.

According to the *Elizabeth City Independent*, the situation came to public attention when Levine Stetson of Colington claimed that the Dare County Board of Commissioners was allowing discriminatory practices by charging some members of the community to cross the bridge while issuing passes to others. Stetson pointed out that average Coast Guard salaries ranged from $60 to $250 per month, which was more money than some local fishermen might see in an entire season.

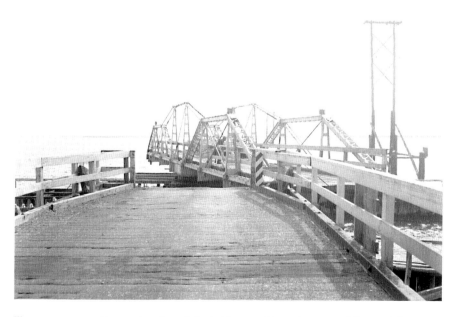

To save money on the construction of the bridge, an old trestle was used from a defunct bridge in the former logging town of Buffalo City on the Dare mainland. *North Carolina Department of Conservation and Development, Travel Information Division, State Archives of North Carolina, September 1949.*

While Stetson noted that he was amiable with all of the commissioners, he said that if necessary he would take the issue to court, stating that he should not be expected to pay while others were receiving free passes. In the end, it was decided that only official cars and trucks of the CCC and transient camps and those who purchased annual passes for seventy-five dollars would be allowed a free ride. Others would either need to pay the toll or purchase coupon booklets.

The toll was abolished when the state took over the Roanoke Sound Bridge. It was replaced in the early 1960s and then again in the 1990s. Both replacements have borne the name Washington Baum Bridge as a tribute to the man who envisioned a more connected Outer Banks.

THE NAGS HEAD BEACH CLUB

The Nags Head Beach Club was built on the oceanfront in time to open for the 1934 summer season. The hip-roofed building (which stood where the Bonnet Street beach access is today) was surrounded by comfortable porches twelve feet wide with exposed beams.

According to Manteo native Frank White, "Folks sat on the porch in rocking chairs in the afternoons," and he added that there were evening activities, especially dancing. Bands from Elizabeth City and Norfolk provided the music. "Not famous groups," he said. The principal investor was Elizabeth City's Braxton Dawson, who at the time of the Nags Head Beach Club's opening was negotiating with the orchestra the Carolina Buccaneers.

A July 1934 newspaper article described the layout of the interior. "A ship's rail will enclose the floor and the tables will be outside the rail. The orchestra platform will be arranged so as to resemble a ship's bridge, with a regular bridge rail and a ship's wheel and a bell."

Dare County residents, owners of beach cottages and those who spent more than thirty days at the beach every year were eligible for membership. Nonresidents and those spending less than thirty days at the beach were allowed admission by a cover charge.

"I often managed to get to the Sunday Tea Dances, despite my age," said Connie Brothers, whose mother managed the Hotel Nags Header

Floor show at the Nags Head Beach Club. Cast members from *The Lost Colony* often performed at the Beach Club on Saturday nights. *North Carolina Department of Conservation and Development, Travel Information Division, State Archives of North Carolina, 1948.*

Count Milgrom and his orchestra. *North Carolina Department of Conservation and Development, Travel Information Division, State Archives of North Carolina, July 1939.*

(built just north of the Nags Head Beach Club in 1935) from 1937 to 1939. "There I occasionally jitterbugged with Joe Perry, a shoe salesman from Elizabeth City who cut quite a rug and was kind to little girls. The big bands came there, but I particularly remember one all-girl band which quite astounded everyone."

An advertisement from the summer of 1935 announced dancing at the Beach Club every night, with a cover charge of $0.75 per couple ($0.35 for extra ladies) and $1.50 on Saturdays and Sundays ($0.75 for extra ladies). Tuesday night was reserved for square dancing. Tobacco buyer Harry Cawthorne, who summered at Nags Head, called the figures.

The Nags Head Beach Club was also the scene of late-night entertainment. The cast and crew from *The Lost Colony* congregated there after performing at Waterside Theater to once again go on stage in acts

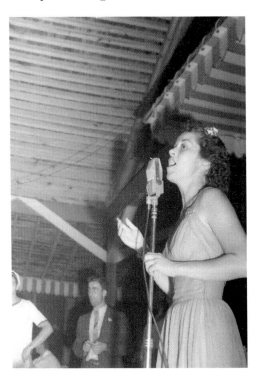

that were spontaneous and improvisational. White said, "For the area and the day it was risqué." He recalled Ruthie Thomson, who sang with the Westminster Choir (the ensemble that performed with *The Lost Colony* in its early years), was one of many cast members who frequented the nightspot after their Saturday night performances on Roanoke Island.

Another entertainer at the Nags Head Beach Club was Andy Griffith. Brothers reminisced, "I actually got to stay up one night to see the after-hours comedy routines put on by Andy Griffith and others after they finished *The Lost Colony*. I wasn't a bit

A songstress at the Nags Head Beach Club. *North Carolina Department of Conservation and Development, Travel Information Division, State Archives of North Carolina, July 1939.*

surprised in my late adolescence that his 'What It Was, Was Football' was such a success."

The Nags Head Beach Club was eventually moved off the oceanfront to an interior lot on Admiral Street in Nags Head. Today, it receives guests as the Nags Head Beach Inn Bed-and-Breakfast.

THE ROANOKE ISLAND HALF DOLLAR

In addition to the debut of *The Lost Colony* outdoor drama in 1937, other events were planned to commemorate the 350th anniversary of the birth of Virginia Dare, one of which was the issuing of a commemorative half dollar to be sold by the Roanoke Colony Memorial Association of Manteo and the Roanoke Island Historical Association.

An act was passed June 24, 1936, to authorize the minting of "not less than twenty-five thousand silver 50-cent pieces of standard size, weight and composition and of a specially prepared design to be fixed by the Director of the Mint." Another stipulation in the bill was that no coins were to be issued after July 1, 1937. Twenty-five thousand of the Roanoke Island commemorative half dollars were minted in Philadelphia in January 1937, and then a second minting took place in June 1937, just before the July 1 deadline.

Baltimore sculptor William Marks Simpson, who designed a coin to mark the bicentennial of Norfolk, Virginia, as well as the seventy-fifth anniversary of the Battle of Antietam, created the look of the Roanoke Island half dollar. The front featured a profile headshot of Sir Walter Raleigh (complete with feathered hat, ruff collar and earring) that closely resembled actor Errol Flynn. Around the time of the issuing of the coin, Flynn played the role of Earl of Essex in the film *The Private Lives of Elizabeth and Essex*, and it was thought that Simpson based his Raleigh on Flynn. However, the film was released two years after the coin, so the resemblance is surely a coincidence.

The reverse of the half dollar depicted Eleanor Dare holding baby Virginia in her arms and was inspired by a vision Simpson had on a visit to the Outer Banks to discuss the details of the design of the

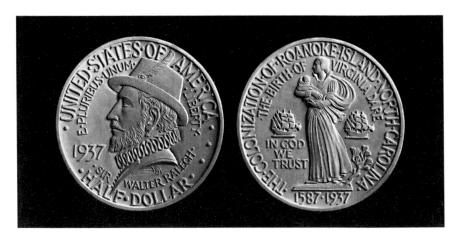

Fifty thousand Roanoke Island half-dollars were minted in 1937, but sluggish sales caused twenty-one thousand to be returned to the Philadelphia Mint. It was designed by Baltimore sculptor William Marks Simpson. *David Miller.*

commemorative coin. After his meeting on Roanoke Island, Simpson was on his way back up the beach when he decided to visit the Wright Brothers National Memorial.

He arrived just as the site was closing and was stopped by the guard. As Simpson began to explain his desire to see the monument, as well as the fact he would probably not soon return to the area, he was struck by the sight of the guard's wife holding their baby.

The 1937 *Lost Colony* souvenir program included Simpson's reflections about his creative vision. "I've suggested the young woman holding her child to her breast gazing far off to the horizon beyond the ships. The sea breeze whips her clothing. I've modeled her standing there courageously, facing uncertainty with pride and determination, but always with the thought of her native England."

Unfortunately, the release of the Roanoke Island half dollar came at a time when many commemorative coins had been issued (sixteen in 1936 alone), and their popularity was dwindling. For that reason, about twenty-one thousand of the Roanoke Island half dollars were returned to the Philadelphia Mint, leaving a circulating lot of about twenty-nine thousand. Most of these were purchased by collectors and others with ties to *The Lost Colony.*

THE MANTEO FIRE OF SEPTEMBER 1939

Although Manteo experienced fires before and after, the conflagration of September 11, 1939, was the most destructive to the town. According to Angel Ellis Khoury, author of *Manteo: A Roanoke Island Town*, the fire "was not totally unexpected." The combination of "crowded wooden buildings two generations old, mixed with the dangerous combination of three industrial oil facilities," which were located along the waterfront, proved to be lethal to the downtown area. Sixteen commercial buildings (about two-thirds of the business district) were destroyed. Fire departments responded from Elizabeth City and Norfolk and were aided by a number of coastguardsmen. Newspaper headlines declared the town gutted.

Edna Evans Bell wrote of the destruction in her memoir, "My Birthplace and My Home." "Fire caught in a storage room of the Standard Oil Company, which was located on the waterfront…every building on the waterfront for two blocks up to R.C. Evans store burned. Some of the owners were able to save part of their possessions by evacuating."

At the time of the fire, the Civilian Conservation Corps had a camp near Mother Vineyard on Roanoke Island, and ninety-five young men from Camp Virginia Dare assisted in saving and protecting government property during the blaze. Harry A. White, the chief foreman of construction and maintenance for the Bureau of Biological Survey, with the Pea Island Migratory Wildlife Refuge, wrote a letter the day after the fire, describing the work of the young men:

I gave orders for the CCC men not to go in the fire, or within a block of the explosions, but to evacuate first the US post office. This was completed within a very few minutes, and all material from this place was loaded on one of the CCC trucks and taken away from danger. The second place to be evacuated was government offices, over the rondez-vous recreation hall. These records and other materials were carried to the outskirts of the business section, and a man was detailed to maintain watch to prevent pilfering, and otherwise destroy them.

The third place excavated was the NYA workshop. After this material was loaded on the truck it caught fire and we had to unload very rapidly

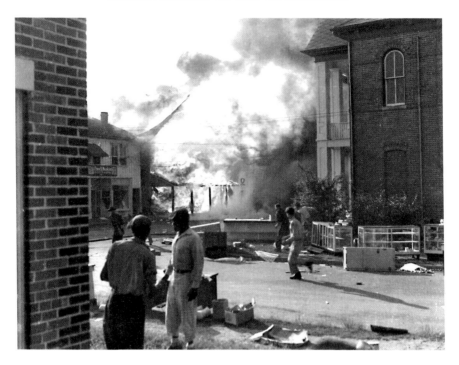

Buildings along the downtown Manteo waterfront during the 1939 fire. Some businesses were able to save merchandise by moving it into the street. Many new brick buildings were built in downtown afterward, and many of those survive today. *Ben Dixon MacNeill Collection, Outer Banks History Center, 1939.*

to prevent the loss of the truck. As a result quite a bit of the NYA material were lost. It consisted of quantities of cotton yarn and other inflammable material and once on fire, the task of extinguishing it was almost impossible. The 4th place evacuated was the Dare County courthouse, all records and other movable equipment was evacuated and carried to safety on the outskirts of the town and again a man was detailed to maintain constant watch over it.

All in all, Manteo rebounded quickly. In 1939, all eyes were on the future of the development of the area. *The Lost Colony* had just finished up its third production season and was proving to be a popular draw, as was the Wright Brothers National Memorial in Kill Devil Hills, which was dedicated in 1932. In addition, plans were in the works for the establishment of the Cape Hatteras National Seashore.

It was reported that merchants who were fortunate enough to have rescued their merchandise before the fire claimed it temporarily set up shop in "barns, warehouses, and even private homes." Bell attested to the spirit and resilience of the merchants. "All the people affected by the fire showed the same courage, and it was not long before the whole waterfront was rebuilt with modern brick buildings."

Summering with Miss Mabel at Camp Seatone

Mabel Evans Jones owned and operated Camp Seatone, which, according to camp literature, was for the training and happiness of boys and girls from six to thirteen years of age. Jones grew up in Manteo, where her parents ran a store and hotel. After receiving an education at Greensboro College in the piedmont section of North Carolina, Jones enjoyed a career teaching in Alabama for a number of years. She returned to Roanoke Island in 1920 and was named the first Dare County school superintendent and also had the distinction of being the first female school superintendent in the state.

Soon after her appointment to her new position, Jones, then still Mabel Evans, learned of the North Carolina Board of Education's plan to create a movie about the state's history. Her Roanoke Island roots helped her persuade the state superintendent of public instruction that the feature film should be about Sir Walter Raleigh's lost colonists. She wrote the script, recruited more than one hundred island residents and neighbors from the Albemarle region to take on roles and even played the part of Eleanor Dare in the 1921 silent film herself.

After furthering her education at the University of North Carolina and earning a master's degree from Columbia University in New York, Jones returned to Roanoke Island, and in the summer of 1935, she began Camp Seatone. The grounds were waterfront on the northeast side of Roanoke Island. Inspired by an architecture course she took at Columbia, Jones designed all five of the camp's buildings.

In a 1973 newspaper article, Jones estimated that she hosted about thirty-five campers each year. In addition to local island children, attendees (most of whom had a connection to the Outer Banks or knew

Enjoying the shallow Roanoke Sound at Camp Seatone. Owner and director Mabel Evans Jones estimated that she hosted thirty-five children each summer. *LeVern Davis Parker, circa 1940.*

Miss Mabel, as she preferred to be called) came from North Carolina towns and from states along the Atlantic and Gulf coasts. She was ably assisted by an impressive list of counselors and instructors. The summer was divided into two four-week sessions. Campers could attend one or the other or both. Local kids could participate as day campers, returning to their homes each night.

Children were grouped by age, gender and, most likely, maturity level. The oldest boys were the Sharks, while younger boys were known as Jack Tars or Shrimps. Girls were either Mermaids or part of the Set-Sail crew.

Camp Seatone's waterfront location provided for activities such as sailing, rowing, fishing and crabbing. Campers could also play tennis, volleyball or shuffleboard and try their hand at archery or horseback riding. Crafts were also taught, especially creating toy boats to race in the sound. After lunch and rest time, afternoons were spent working on dance and rhythms. Board games and a library of "well-chosen books" were provided on rainy days or at quiet times. Parents could arrange for tutoring.

Trips were taken to local attractions such as the Wright Brothers National Memorial, Bodie Island Lighthouse and *The Lost Colony*, and on calm days, children visited the Nags Head Beach Club for ocean swimming.

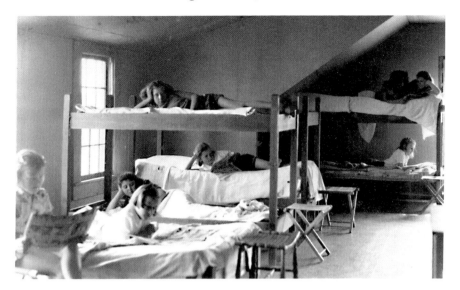

The interior of one of the resident cabins reserved for Camp Seatone's female campers. *LeVern Davis Parker, circa 1940.*

With her attention to detail, in camp literature Jones gave parents advice on writing to their child. "[W]rite frequently with happy praise," she suggested, "but never the 'my child, how we do miss you.'"

In mid-August, the end of the season was marked with pageants, boating and swimming races, diving stunts and the presentation of awards for categories such as "Best All-Around Camper" and "Most Development While at Camp."

Seatone ceased operations during World War II and

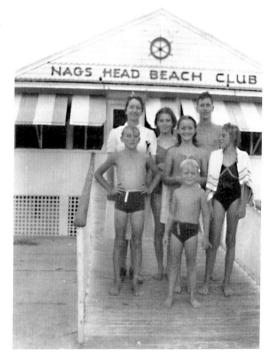

Campers were often treated to a trip to Nags Head for an afternoon of beach play and a dip in the ocean. *LeVern Davis Parker, circa 1940.*

was never reopened. Perhaps Miss Mabel wanted to spend quiet time with her husband, Roanoke Island's Onslow J. Jones, a lifelong friend she married in a quiet ceremony in 1939.

FIRE ON THE SEA: THE SINKING OF MERCHANT SHIPS OFF THE ATLANTIC COAST

In the months following United States' entry into World War II after the Japanese bombing of Pearl Harbor, a frightful story unfolded along the Atlantic Coast. German submarines, known as U-boats (short for the German *Unterseeboot*), stalked and destroyed merchant ships along the East Coast. Between January and June 1942, the U-boats sank scores of ships with the loss of hundreds of lives.

Admiral Karl Dönitz, commander of Germany's U-boat fleet, suspected that the United States was unprepared to defend its eastern seaboard. During the first half of 1942, while Americans slowly converted to a wartime mentality, shipping interests paid a great price both in lives and goods. Dönitz requested the use of twelve U-boats to be dispatched to the western Atlantic, a plan he called *Paukenschlag*, or Drumbeat. The admiral, however, only received the use of five vessels, which set out for the western Atlantic in late December 1941. More would follow.

While various ships fell victim to the German submarines, choice targets were tankers—oversized ships carrying oil from South America, Texas and the Dutch West Indies. Their size and speed made them easy prey, while at the same time, it deprived the United States and its allies of valuable fuel. A particularly gruesome aspect of the torpedoed tankers was their highly combustible cargo. Great burning slicks floated on the water and caused the nefarious demise of many a poor seaman. Survivors were brought to hospitals along the coast to receive treatments for the terrible burns they received. For a time in late April 1942, all tanker travel north of the Florida Straits was suspended.

More often than not, U-boat strategy was to strike at night, remaining out of sight during the day and surfacing under the cover of darkness. Lighted ships were easy targets, but even those traveling without lights could be

silhouetted against the illuminated shores of America's East Coast cities. As a result, either onshore lights were extinguished altogether or windows were covered with heavy black curtains. Automobile headlights were covered so that only a thin strip of light could be emitted, just enough to see to drive. Although the government urged communities to blackout at night, stubborn merchants resisted, claiming that it was bad for business. Military towns such as Norfolk, Virginia, and Newport, Rhode Island, were easier to persuade than the resorts of Atlantic City and Miami.

The first wave of the U-boat invasion targeted the waters between the St. Lawrence River and Cape Hatteras. Lags in sinkings gave Americans false optimism that they were over, but in time, the sinkings continued. Later, *Paukenschlag* was extended to include the waters off Florida.

Coastal residents felt the explosions at sea, which were often strong enough to shatter windows. Tankers were seen burning at night, aflame

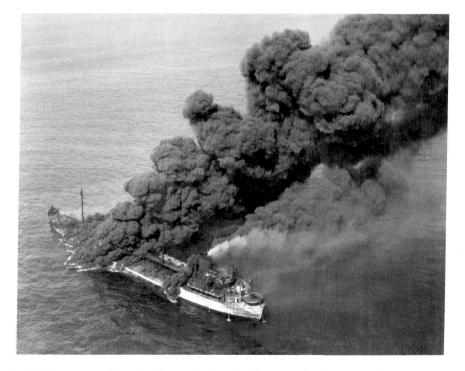

This ship was torpedoed by a German U-boat. Tankers were favorite targets for enemy submarines. During March 1942, an average of one merchant ship per day was torpedoed off the North Carolina coast. *Library of Congress Collections, 1942.*

at sea. Washed up on the beaches, they found oil and wreckage, as well as the occasional grim discovery of a body.

March 1942 was a particularly destructive month, with an average of one ship a day being lost. U-boats sank three tankers and two freighters off Capes Lookout and Hatteras in one night alone. Although many lives were lost during the first six months of 1942, others survived the U-boat attacks and lived to tell about them. Anna Zurcher, a Swiss passenger aboard the *City of New York*, survived a U-boat attack on March 29 and kept a diary of her thirteen-day odyssey in a lifeboat before being spotted by an airplane and rescued by a Coast Guard cutter. On day seven, she wrote, "Boils and pimples from the salt spray and lack of vitamins are starting to appear and everybody's fingernails are blacker than ever, faces are just coated with dirt."

In addition to the stories of men, women and children rescued from lifeboats, others clung to wreckage before being saved. After his ship *Alcoa Guide* sank off the North Carolina coast, Jules Souza floated on a makeshift raft for more than a month before rescue.

The U-boat captains referred to this period as the "Second Happy Time" (the first being the summer and autumn of 1940, after the U-boats operating out of French ports wreaked havoc on merchant vessels), easily picking off lone ships at sea. It wasn't until April 14, 1942, that the first U-boat was destroyed in the eastern sea frontier. The USS *Roper* sent the *U-85* to a watery grave, and within a month, the Coast Guard Cutter *Icarus* had sent the *U-352* to the same fate.

British officials urged the United States to employ the convoy system, which England found successful in reducing U-boat attacks. Groups of ships traveled together, making an attack less likely. All vessels moved at the same speed, with faster patrol boats circling. Large commercial vessels traveled in the middle, with smaller escorts on the perimeter.

America began to perfect its antisubmarine warfare tactics. By the summer of 1942, the number of ships sunk by German invaders had dropped with the implementation of the convoy system, additional boats patrolling the coast, successful air surveillance and attacks on the U-boats. One can only surmise what might have happened if earlier that year Hitler had allowed Dönitz the dozen U-boats that he requested in late 1941. Indeed, the war could have taken a different direction.

Part III

BAREFOOT AND TAN, 1945–PRESENT

AVALON BEACH:
AN EARLY OUTER BANKS SUBDIVISION

Avalon Beach, which flanks the US 158 Bypass at Milepost 6 in Kill Devil Hills, was one of the first subdivisions on the Dare County beaches. Started by a developer from Florida, it was later owned by Clarence "Shug" York and developed by Robert Young.

An early brochure read, "The largest improved development in the area, Avalon Beach consists of over 1,100 full size lots being improved and sold since June 1950. Since that time, 120 modern beach cottages have been built by individual purchasers and more and more are going up all the time. In fact, improvements including 7 miles of concrete streets, now total over a million dollars."

A strategic marketing plan targeted the middle class, especially shipyard workers from the Tidewater, Virginia region. Some streets were named for south-side and peninsula cities—Hampton, Norfolk, Newport News, Suffolk and Phoebus—in an effort to sway Virginia residents into investing.

Potential buyers received a letter explaining that a lot had been "allocated" for them at Avalon Beach. When recipients visited the subdivision expecting to be given a lot, the salesman feigned a misunderstanding, explaining that the lots were actually for sale. The salesman then offered to talk to his

manager and would return delivering the good news that the price of the lot would be reduced to make up for the inconvenience.

Carroll Young (no relation to Robert) lived in a house on the corner of Wilson Street and the bypass between 1959 and 1963 and helped build many of the early structures in Avalon Beach. "The cottages were very scattered," he said in a 2007 interview, adding that most houses were of block construction on concrete slab foundations with flat roofs. Some had masonry fireplaces, and most didn't have heating or air conditioning. Many of the cottages had screened porches across the front, and it "was plenty cool" at night.

This was back when Kill Devil Hills had only 103 registered voters and 2 men who made up the police force. "Labor Day weekend would come a crowd, but by Tuesday, it would be a ghost town. At night you might see one or two lights off in the distance," Young reminisced.

By the 1980s, several of these smaller houses on fifty- by one-hundred-foot lots had become first homes for those just starting out (including the author of this book). Maria Wise moved into Avalon Beach when she got married and recalled, "The whole neighborhood was full of people

An early cottage in the Avalon Beach neighborhood in Kill Devil Hills. While many early cottages lacked air conditioning and heat, they included fireplaces for the cooler months and screened porches to catch breezes off the ocean and Kitty Hawk Bay. *Roger Meekins Collection, Outer Banks History Center, circa 1950.*

our age." This led to a unique blend of neighbors. Older cottage owners intermingled with young couples and families who either rented or were investing in their first homes.

The area west of the bypass was often referred to as "West Avalon." Locals added the word "Lower" to the title and thus dubbed it "West L.A.," giving the area a fashionable identity. Surely the moniker stemmed from a cut on the Grateful Dead's 1987 album *In the Dark*, "West L.A. Fade Away."

Being that the lots were small, we lived very close to one another. On Sunday afternoons, when the Washington Redskins were playing, you could hear cheers or cries of agony coming from many of the cottages. At night, when a cold front came through, you could hear everyone's loose stuff blowing around, especially flowerpots falling off the neighbor's deck rails.

Although this was before K-Mart and the Dare Center Shopping Center, Avalon Beach had its own shopping district. The Kill Devil Hills Superette-Launderette was a combination service station, convenience store and laundromat. The washer-dryer area was adjacent to the store, and both were open twenty-four hours a day. Many of the Avalon homes were without laundry facilities, so it was a popular spot.

Over on Beach Road, Skippers Market (formerly Avalon Market), although opened seasonally, was a wonderful neighborhood grocery store. Awful Arthur's was close enough to walk home from in case you had one too many, and the Jolly Roger was a favorite place for breakfast, especially on Saturday mornings during the winter.

Chuck Ball has owned a home in Avalon for more than fifteen years. His family originally "bought a little place to come down to the beach." Over time, they have gotten to know the neighbors, whom he described as "an eclectic bunch." His wife, Lesley, served as president of the Avalon Beach Improvement Association.

Neighborhood property owners share interest in an oceanfront beach access, as well as a sound-side access. Ball credited the late Walter Jones, who lived on Suffolk Street for many years, as being instrumental in getting the neighborhood's common property (which fell into arrears when taxes had not been paid) classified with a nonprofit status. "He saved the lots for the enjoyment of Avalon residents. It's the only development with its private ocean access that's now protected and kept in perpetuity."

Ball admitted that energy has waxed and waned in the Avalon Beach Improvement Association as new people move into the neighborhood. When property values rose, "People put a lot more money into these little houses. It's still a hodge-podge. You can see every type of architecture from flat tops to McMansions."

THE VALENTINE'S DAY FOX HUNT

Ever since the modern era of tourism was ushered in after World War II, community leaders have been eager to extend the season and attract visitors during what is known as the shoulder seasons—chiefly spring and fall. The Nags Head Surf Fishing Tournament, held each October for more than sixty years, is an example of a shoulder season activity, as is the OBX Marathon.

An early attempt to attract winter visitors to the Dare Beaches was the Valentine's Day Fox Hunt, headquartered at the Carolinian Hotel. The tradition began in the late 1940s and was described as an "unusual off-season attraction during the winter month of February when tourist travel in Nags Head is normally at a low ebb."

Signaling the hounds at the inaugural Valentine's Day Fox Hunt. The annual event was held in Nags Head Woods, Colington and Bodie Island. *Aycock Brown Collection, Outer Banks History Center, 1949.*

The hunt began with the blessing of the hounds, which were brought in from places such as Suffolk, Portsmouth and Louisa Courthouse, Virginia, as well as Louisburg, Oxford and Murfreesboro, North Carolina. Temporary kennels were constructed in the Fresh Pond area, a short distance from the Carolinian.

On the morning of the event, the dogs were released at 7:30 a.m. The hunt continued until noon. What made the

Valentine's Day Fox Hunt different than traditional fox hunts, where the fox is chased by dogs and followed with riders on horseback, is that the fox and hounds were followed by riders in jeeps and four-wheel-drive vehicles.

Keep in mind that the land was much less developed, and there was a great amount of open space. Colington was a favored location to chase the foxes, and Nags Header Jim Lee, who worked for the North Carolina Wildlife Resources Commission and photographed the event in 1959, remembered "jeeps and pickup trucks all over Bodie Island and into the Nags Head Woods. Most of us drank to excess, which was just as well for the foxes."

In addition to the hunt itself, guests were treated to dances in the evening, breakfast before the day's activities, hospitality sessions and a horn-blowing contest. By the 1960s, the hunt had been pushed back into March and April, but by 1972, the idea of the fox hunt had become passé.

Hunters encounter soft sand during the inaugural Valentine's Day Fox Hunt. Loss of open space to hold the hunts contributed to their demise. *Aycock Brown Collection, Outer Banks History Center, 1949.*

The Dare County Humane Society cited three North Carolina statutes that made the fox hunt illegal. One law forbade killing an animal unless it could be proved that it had maimed or killed livestock or pets. Another code outlawed cockfighting, bear baiting and other amusements that pitted one animal against another. The third law made cruelty to animals a punishable offense.

Local newspapers from March 1972 published the week before the hunt were filled with letters to the editor from both locals as well as out-of-towners expressing opposition to the fox hunt. In order to maintain peace and keep law enforcement away from the hunters, the event that year was held in Currituck County.

In the end, 1972 proved to be the final year of the fox hunt. The reason given by Ed Lamm, who acted as assistant master of the hunt, was not the pressure placed on hunters by the anti-cruelty forces but instead increased development that had taken place during the twenty-five-year history of the hunt that had reduced the free space and open lands previously used for hunting.

THE GOVERNORS' VISIT OF 1957

The Outer Banks, rich in natural beauty, historic attractions and recreational opportunities, have always been a feather in the cap of the Tar Heel State. Astute politicians have been able to use the area to show off and host important guests. Such was the case when North Carolina governor Luther H. Hodges hosted a group of governors from across America on a trip to the Outer Banks during the summer of 1957. Hodges extended his invitation at the Governors' Conference in Williamsburg, Virginia, June 25–27.

Following the conference, eleven state executives of both political affiliations—Pat MacNichols of Colorado, Hershel Loveless of Iowa, George Docking of Kansas, William O'Neill of Ohio, Orville Freeman of Minnesota, William G. Stratton of Illinois, J. Hugo Aronson of Montana, J.E. Davis of North Dakota, Joe J. Davis of South Dakota, George Clyde of Utah and George Bell Timmeran Jr. of South Carolina—and their families were treated to a stay on the Outer Banks.

Mrs. William O'Neill places a wreath at the Wright Brothers Memorial in Kill Devil Hills to pay tribute to fellow Ohioans Wilbur and Orville Wright during the visit of the governors. *Aycock Brown Collection, Outer Banks History Center, 1957.*

After arriving at the Manteo Airport, the group toured the Fort Raleigh National Historic Site and Elizabethan Gardens. As always, the Carolinian Hotel, in exceptional Dare coast style, offered the governors and their parties complimentary oceanfront accommodations in Nags Head. The Kitty Hawk Land Development Company, spearheaded by David Stick, hosted a luncheon at the Sea Ranch Hotel in Southern Shores. Afterward, the group of dignitaries toured the Wright Brothers National Memorial, where Mrs. William O'Neill, the first lady of Ohio, placed a wreath in honor of Wilbur and Orville Wright.

The group reassembled at the Carolinian Hotel after the afternoon events. Hotel staff entertained the children of the governors while the adults attended a yaupon tea party. An entourage departed at 7:45 p.m. for a special preview viewing of *The Lost Colony* drama on Roanoke Island.

The next morning, army helicopters transported a group to Hatteras Island (this was before the construction of a bridge across Oregon Inlet) for participants to try their hand at offshore fishing. The catch of the day went to Dubby O'Neill, son of Ohio governor William O'Neill, who landed a twenty-pound dolphin that was reported to be as long as the angler was

tall. For the governors who preferred freshwater angling, bass trips were arranged in the waters off Colington and Kitty Hawk. Mrs. Hodges hosted a sightseeing boat trip inshore, cruising around Roanoke Island.

While some of the party disbanded at the end of the two-day jaunt, others stayed on through the weekend, enjoying a bit more local hospitality and making more Outer Banks memories.

SAM JONES:
SELF-MADE MAN AND LOVER OF OCRACOKE

This is a story about Sam Jones. It starts with his birth in 1893 in Swan Quarter, North Carolina, in Hyde County. As a young teen, he left to seek his fortune, and in 1915, he took a job at Berkley Machine Works and Foundry in Norfolk, Virginia. By the time Jones was thirty, he owned the company and, consequently, became a prosperous man.

Sam Jones discovered Ocracoke in the late 1930s and immediately fell in love with the island. He built the Berkley Manor and the Berkley Castle. He used the castle for entertaining potential clients of Berkley Machine Works. (This eventually caused Jones problems with the Internal Revenue Service, but that is a different story.)

Along with Ocracoke, he loved its people and employed many residents as cooks, caretakers, musicians and hunting and fishing guides following World War II, after the navy closed its base on the island. In the true fashion of a wealthy eccentric, he was a giver of gifts. "He introduced butter cookies to the island," Ocracoker Gene Ballance said. "Now you see them everywhere. He was the first person to give away butter cookies."

"He would lavish stuff on me," said the late local author and historian David Stick, who recalled taking his family to the Pony Island Restaurant. When he asked for a menu, the waitress reported, "Your meal has already been ordered and paid for by Sam Jones." Later, Stick took his family to thank Jones. "I can't remember what he gave the boys, but he gave Phyllis and me some cast iron doorstops shaped like ducks."

David Stick had been in the market for an executive chair and saw one in Jones's office. "There's the chair I've been looking for," he mentioned

Sam Jones at the Berkley Castle with his beloved banker pony, Ikey Dee. Jones died in 1977 and is buried next to Ikey Dee at Springers Point on Ocracoke Island. His epitaph reads, "I shall pass this way but once any good therefore that I can do let me do it now, for I shall not pass this way again." *Aycock Brown Collection, Outer Banks History Center, circa 1950.*

to his wife. After arriving home, he received a telephone call from Sam Jones. "How do you get to your place at Colington?" he asked. "I'm sending you something." Stick was not surprised when an executive chair identical to the one he had seen on Ocracoke was delivered.

Julie Howard, former director of the Ocracoke Preservation Society and longtime Ocracoke resident, shared some poignant memories of Jones's generosity and character:

> *The one thing I can tell you—and total fact. One night at choir practice, on a Thursday night, the back door of the church flew open, and in came Sam Jones with the guy who was his pilot and photographer…I don't think Sam was carrying anything, but the pilot was carrying a stack of dress boxes full of dresses for the choir and me, and he came*

up and passed them out. He knew which one was for which person, and the thing that was so amazing to me…the dress fit me. How did he do that? How did he know what size I was? How did he do those kind of things?

He came in, handed out the dresses and exited about as fast as he came, and it was sort of like a little whirlwind and swish out he went and left all these expensive dresses behind. Mine had like a $120 price tag on it, and this was in probably 1975 or 6. It was back when that was a lot of money. I don't know if I had any one-on-one conversation with him because he didn't stay still very long. He was always on the go doing things, from my perspective anyway. That's how he was geared.

Jones's personalized stationery attests to his drive. The eight- by eleven-inch paper is heavily bordered by his favorite motivational sayings and quotes from those he admired, such as Ben Franklin and Abraham Lincoln. "Everything comes to him who hustles while he waits" and "The best way to kill time is to work it to death" were two of his own slogans.

Sam Jones was also instrumental in paving the airstrip on Ocracoke, which had been described "at best a grass strip and at worst a sandy dirt strip." Jones enlisted the help of Judge Albert W. Cowper from Lenoir County, North Carolina. Cowper, another lover of Ocracoke, was an avid sailor who would sail to the island from Oriental, North Carolina. Cowper suggested that Jones talk with Representative Tom White Jr., also from Lenoir, who in addition to being an outdoorsman with a penchant for Ocracoke was chairman of the North Carolina Senate Finance Committee.

The argument for a paved airstrip on Ocracoke was for emergencies. There was no talk of using it to promote tourism. In the early 1960s, an appropriation was approved. Jones's plane *Carrousel* was the first aircraft to land at the newly improved and newly dubbed Cowper-White Airport.

Jones also helped fund projects for the local Boy Scout troop, gave money to Ocracoke churches and is reputed to have donated money for the Ocracoke Fire Station. "There are probably as many Sam Jones stories as there are stars in the sky. And everybody you talk to will have a story," said Howard. "He was just really interesting."

BOB THE SURFER

For a short time in the summer of 1965, an outlaw plagued Dare County law enforcement officers. Although the true identity of said desperado was eventually discovered, he went by the moniker "Bob the Surfer." I shall not reveal his name, for the sake of mystery.

According to accounts in the *Coastland Times* newspaper, "Bob the Surfer" hailed from the New York City area. He was described as "normal in appearance, about 145 pounds, 5 feet 9 inches tall, dark brown hair, haircut in the California surfer style."

Bob and a male companion began their trouble with the law after breaking into an Avalon Beach cottage owned by Mrs. Knight. Knight's brother, Sherald Ward, met and befriended Bob earlier in the week. It was reported that Bob even spent a few nights at the Knight cottage. Ward told Bob that he could no longer stay at the cottage because of incoming renters for the upcoming Memorial Day weekend.

The Saturday of the holiday weekend, Bob and the companion left a Nags Head drinking establishment and returned to the Knight cottage, the companion being led to believe that they were invited. Upon arriving, one of the trespassers entered through a window and the other through the door. Said breaking and enterers then proceeded to pick up and drop a television set.

Law enforcement arrived at the house at about 1:00 a.m. and spotted an open window and barefoot tracks in the yard. Inside was a broken television and what appeared to be "beer all over the floor." Kill Devil Hills police chief Thomas Dowdy followed the footprints in the yard and discovered Bob and his companion asleep in a car.

After fingerprinting at the Dare County Courthouse, Bob pulled a fast one, slammed the door of the sheriff's office and escaped. Dare County sheriff Frank Cahoon made a valiant effort to catch the lad, who was a "particularly agile, and an excellent swimmer and surfer." But Cahoon, being forty years his senior, was unable to catch him.

When he made his getaway, it was reported that "Bob the Surfer" was barefoot and wearing a T-shirt and shorts, but by midweek, he had

acquired a raincoat and a pair of sneakers. Later testimony revealed that he procured the clothing from fences and clotheslines.

Following Bob's flight from the Dare County Courthouse, all available law enforcement, including members of the Dare County Sheriff's Department, North Carolina Highway Patrol and even the National Park Service, was enlisted to help apprehend the youth. To keep the rider of waves from escaping Roanoke Island, twenty-four-hour roadblocks were placed at the Washington Baum and William B. Umstead Bridges.

When Bob was spotted in Wanchese, hanging out and drinking beer, a fire was set in the marshes, in an attempt to "smoke out" the perpetrator. While the fire concerned island residents, it did not produce a suspect.

Eventually apprehended, in the end "Bob the Surfer" was sentenced to three months for theft, which was waived to a $25 fine and other costs, and six months for escape. He was bound over to Superior Court on a $500 bond. A number of young people were present for the sentencing, and at times laughter erupted during testimony. Judge Vannote, in charge of the proceedings, issued a warning that if the laughter did not stop, the snickerers would be thrown out of the courtroom.

The *Coastland Times*, being an evenhanded newspaper, soon afterward ran a pro-surfing article under the headline "Despite Bickering Amongst Selves: Surfers Try to Change Image from Bad to Good," giving local wave-riders a chance to tout the benefits of their sport.

Reporter Bob Hass wrote, "Most of the surfers are good kids who wouldn't make trouble for anybody. But there are a few who spoil the broth. Guys like 'Bob the Surfer' and 'Murph the Surf' (involved in a big diamond robbery) get all the publicity."

In order to combat the negative image associated with surfers, two surfing clubs were formed. Sherald Ward, known as "the Governor" or simply "the Gov," headed the Kitty Hawk Surf Club, while Leigh Forbes and Larry Holmes organized the Nags Head Surfing Association. While the aforementioned article divulged that the two groups were sometime at odds with each other (it is said that Ward and Holmes had strong personalities), community involvement, beach cleanups, water safety and proper conduct in the water were mutual goals of the organizations.

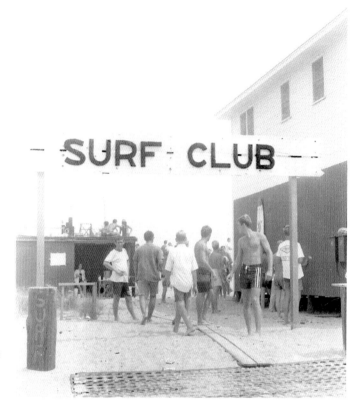

The Kitty Hawk Surf Club was active in 1965 as the sport gained popularity in the area. *Aycock Brown Collection, Outer Banks History Center, circa 1965.*

Surfing continues in popularity on the Outer Banks. Today, surfing events are held at Cape Hatteras and at Jennette's Pier in Nags Head, a testament to the area's desirable waves. The area is also home to a handful of professional wave-riders.

REMEMBERING THE GALLEON ESPLANADE

My first recollection of the Galleon Esplanade was on a trip to the Outer Banks with my mother and brother in the mid-1970s. We must have driven by it a couple of times before Momma couldn't stand her curiosity anymore, and we went shopping. It was, in a sentence, a serendipitous shopping oasis along a sparsely settled strip of sand. I remember Momma gasping as she looked at one high-quality bathing suit after another,

finally settling on a two-piece with a stunning print of strawberry plants, complete with blossoms and fruit.

We then lunched. The architecture of the place was amazing. The Galleon Sportswear anchored the northern end of the complex, which was highlighted by a courtyard of shops in the center. A galleon protruded into the courtyard, which boasted a fountain, benches, statues and a gazebo, all in a landscaped setting. A set of stairs led to a second-floor walkway and entrance to other shops. At the Slice-One Dip-Two Deli, we ordered sandwiches that were three inches thick. Mother spent more money than she had planned.

The Galleon Esplanade was the brainchild of entrepreneur extraordinaire George Crocker, who came to the Outer Banks to seek his fortune at the suggestion of Diane Baum St. Clair. His original business ventures were motels, first the Beacon Motor Lodge and then the Cabana East. Crocker then leased a small sportswear shop across from his motels that belonged to a man named Mr. Trott. (The first year in business, Crocker called this establishment Trott's Galleon.) He found that he enjoyed selling women's clothing and expanded stock to include men's wear and gifts. While the original sportswear shop did an annual business of $12,000 gross, Crocker went forth with "trust and faith and confidence" and practically tripled buying, spending $20,000 on merchandise. In his second year of business, the store was simply known as the Galleon.

After a few successful seasons (Crocker was only losing $4,000 a year, which he considered nominal since he had so greatly expanded the purchasing), he arranged a business deal with the owner of the building and purchased it along with three adjacent lots. George Crocker, a man with a true business sense, immediately expanded the building by converting a former living area in the rear of the building into retail space.

The entrepreneur had found his niche! He quickly became enamored of attending tradeshows in New York City and selecting the perfect clothing and gifts for his shop, ideas for which he continued to visualize. He selected each piece of merchandise and would work all night long unloading stock, pricing wares and presenting them for sale through interesting and attractive displays. In 1967, he won the highest award in the nation for outstanding building design and gift display given by

Gift and Decorative Accessories magazine. Crocker was pleased to learn that Neiman Marcus had come in second behind his beloved Galleon.

One of Crocker's first displays involved wire manikins retrieved from a dumpster, as he had no money to purchase new ones. They were spray-painted black, clothed in bright apparel and placed in front of a black background with a single spotlight on each. This gave the impression that the manikins were floating in space. While quite pleased with his designer window, Crocker became dismayed to learn that customers had an aversion to black manikins. He left them up, not caring if his clientele appreciated the creative aspect of his window treatments.

The store continued to grow in popularity, one year selling more bathing suits than any other shop in North Carolina. Crocker was doing over $1 million of business. Five or six years into the venture, he began to envision what would be a "beautiful building that was out of character… for Nags Head. I could see local people at night riding by when that building, in white stucco with columned arches standing, would ride by and look, and I guess scratched their heads, and maybe other places too, in wonderment of how—had I gone crazy or something." He bricked in the front of the building and framed the windows with stately arches, and a staircase was added inside to create two levels of shopping pleasure. The Galleon was both "glamorous and glorious."

Along the southern portion of the property, a large building was built and divided into smaller specialty shops, each with its own façade. Crocker's reasoning was wise. If a store was not popular or was not doing well, it could be replaced or reworked into something with more appeal. Aladdin's Lamp, Court Jester, A Shore Thing, Queens' Ransom, Things Papa Brings, Silver Lining and the Captain's Log were some of the names of the courtyard boutiques.

One of Crocker's keys to success was establishing a team of top-notch sales associates and managers. "I gave responsibility…I gave authority, and I gave it so clearly that the young people who joined me…knew what they were supposed to do and when and how to do it, the likes of which I don't think we'll ever see again on the Outer Banks." He was also a wise enough leader to delegate, sending sales associate Margie Peterson to select the entire Villager Dress line that would be sold at the Galleon one

summer. When Peterson protested, Crocker told her, "You can do it, and you're going to do it, and you've got to do it, or you're fired!"

Some of the most memorable events the Galleon sponsored were the fashion shows—originally known as "Champagne Teas" and held each spring at the Sea Fare Restaurant. They were fun and festive events that grew to be so popular that reservations were necessary in order to attend. Themes such as "the Orient" were chosen, and lanterns would be used as decorations or shells used to decorate for beach-themed shows. Part of the success of the fashion shows was that local folks were selected to be models. Mary Pool, Ray White, optician Dr. Stoutenburg and author and historian David Stick were among many who served as models. One year, Crocker arranged to have Norfolk television personality Mildred Alexander emcee the show with him.

My first summer living on the Outer Banks, I was asked to participate in a Galleon fashion show—one of the few times I ever modeled. The outfits I was to wear had been selected and accessorized tastefully. We changed at the Galleon, and the fashion show was held in Sinbads

Mary Pool models at a spring fashion show sponsored by the Galleon and held at the Sea Fare restaurant in Nags Head. *Aycock Brown Collection, Outer Banks History Center, May 1969.*

Restaurant across the courtyard. I distinctly remember a table of large lunching ladies shouting out to me, "Hey honey, ya got that in a size 20?" I think I probably blushed at the raucous laughter that erupted from their table. I was rewarded with what I thought was going to be a fifty-dollar gift certificate to the Galleon Sportswear Shop, but I must have heard incorrectly as it turned out to be a fifteen-dollar gift certificate. Shucks, you couldn't buy anything at the Galleon for fifteen dollars!

Another memorable event at the Galleon was the Gambler's Sale, held at the end of the season. Women would come from "all over hell and half of Georgia just to get a bargain." Crocker would have his staff dress up in casino-type attire, and a large gambling wheel was brought in. Shopper's discounts were determined by a spin of the wheel.

Crocker sold the Galleon in 1985. Without his magic sparkle in the mix, the business declined and was eventually demolished a few years later. Crocker went on to have a restaurant, Crocker's, in the Ocean Reef Motel in Kill Devil Hills and also was an organizer of the Outer Banks Community Foundation.

After the Galleon Esplanade was razed, a pile of concrete and twisted steel beams was left for a while, a mortal end to a place that had been so magical. Today, large rental houses occupy the site of the former shopping oasis.

SEARCH AND SALVAGE OF THE *MONITOR*: A LONG AND STORIED PAST

An old chapter is complete and a new one has begun with the opening of the 63,500-square-foot USS *Monitor* Center at the Mariner's Museum in Newport News, Virginia. The state-of-the-art facility, which opened in 2007, features interactive multimedia exhibits and is the premier research facility for those studying the history of ironclads. Visitors are able to learn the story of the *Monitor* and its famous battle with the Confederate ironclad *Virginia* in Hampton Roads and can view conservation work being conducted on the *Monitor*'s turret.

After the battle between the *Monitor* and the *Virginia* on March 9, 1862, which most historians would agree was a draw, the *Monitor* patrolled Hampton Roads and the James River. After a visit to the Washington Navy Yard, where the ship received repairs and renovations, the *Monitor* was to blockade Charleston Harbor in South Carolina. However, while being towed by the USS *Rhode Island*, the vessel was caught in a storm and sank off Cape Hatteras on New Year's Eve 1862. Four officers and twelve crewmen perished.

Locating and salvaging the *Monitor* has been a long, arduous and expensive undertaking. In May 1954, Raynor T. McMullen, a retired postal carrier from Dundee, Michigan, journeyed to Hatteras Island to find the *Monitor*. In his party were a writer and photographer from *Life* magazine. A December 1950 newspaper article by Ben Dixon MacNeill spurred McMullen's idea. He spent $1,000 of his own money, but his three-day search proved fruitless. Not wanting to give up the hunt,

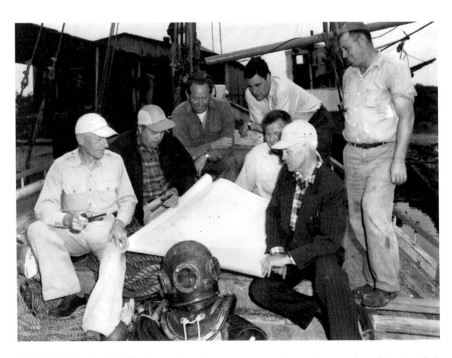

R.T. McMullen (at right in dark suit) and crew prepare to locate the remains of the ironclad *Monitor*. The vessel sank off Cape Hatteras in 1862 while being towed to Charleston, South Carolina. *Roger P. Meekins Collection, Outer Banks History Center, 1954.*

McMullen formed the *Monitor* Historical Society and offered $1,000 to anyone who could locate the ship and turn it over to the society.

The following year, twenty-one-year old marine corporal Robert F. Marx, an experienced diver stationed at Camp LeJeune, claimed that had he located and touched the *Monitor* in fifty feet of water one mile off Cape Hatteras. Those familiar with the ship discounted Marx, believing the location too far from where the ironclad sank. Marx's claims were never investigated nor substantiated, and later excavators called him "a fortune hunter, shunned by the underwater archeology community."

The *Monitor* was finally discovered in 1973, sixteen miles off Cape Hatteras, where it sank 110 years earlier. In order to protect the site, the National Oceanic and Atmospheric Administration (NOAA) named the location a National Marine Sanctuary shortly afterward, the first site to receive such designation.

The capricious nature of technology and the sea are evidenced in the 1983 *Monitor* expedition that included thirty-five researchers from East Carolina University, NOAA and the Harbor Branch Foundation. A newspaper headline reported, "Succession of Goofs and Bad Luck Flusters Scientists Exploring Monitor." To start, when the crew assembled for its brief investigation, the ship was nowhere to be found due to a change in Loran frequencies. Almost an entire day was spent simply finding the *Monitor*. Poor weather conditions led to high seas and low visibility in the murky water surrounding the ship. Archaeologist Gordon Watts explained, "We are getting our rear ends kicked."

To make matters worse, a three-vessel flotilla of reporters surrounded the *R/V Johnson*, the research vessel undertaking the expedition, while a helicopter from a local television station hovered overhead, all poised to capture any archaeological finds as they emerged from the deep.

Recovery of the *Monitor*'s four-pronged anchor was one of the objectives of the expedition, and excitement built as it was located, severed from its chain and affixed to a lift bag that started to raise the 1,300-pound anchor from its resting place. Unfortunately, the lift bag burst, and the anchor broke free. "We are naked to the world," Watts was quoted as saying in the 1983 newspaper account. Days later, in improved conditions, the anchor was raised (this time with two lift bags) and sent to East Carolina

University for study and conservation. This laid the groundwork for the recovery of larger artifacts from the site.

According to Watts, now director of Tidewater Atlantic Research Inc. in Washington, North Carolina:

> *While recovery of the anchor was the most readily apparent success of the 1983 expedition, it was not the most important objective. The most important objective was using stereo photography to document the wreck and generate data for a three dimensional image of the wreck site. Because of complications with the equipment and weather we were not able to achieve those objectives. The anchor did, however, afford the first opportunity to conserve a large object from the site and provided data important in planning for the recovery and conservation of even larger objects such as the machinery and turret.*

An active hurricane season in 1995 contributed to heavy sea currents, which thrice denied navy divers the opportunity to raise the *Monitor's* nine-foot, 3,600-pound propeller. Attempts in mid-August of that year were thwarted as Hurricane Felix spun in the Atlantic. Later that month, under improved weather conditions, ruptured oxygen hoses cut excavation work short. The final attempt made in October was also unsuccessful, as heavy undersea currents made diving difficult.

The tide of good fortune was with the five-week expedition to the *Monitor* in the summer of 1998. Not only were the propeller and eleven feet of the propeller shaft recovered, but equally important was the data collected. Documentation of the wreck site was a primary goal, as well as recovery of exposed artifacts. Researchers captured moving and still photographs, took measurements and observed and surveyed the site. Twice as much dive time was accumulated in 1998 as all other previous NOAA expeditions combined.

On the night of June 5, the propeller was recovered. The all-day effort was temporarily halted when the blade that was cutting through the propeller shaft snapped with only half an inch left to go. As night was approaching (and also foul weather), a large ocean swell swept through the area, causing the ship to lift and the final portion of iron shaft to break free.

Those aboard the ship began to scramble to prepare for their new "shipmate." Any lights on board that were available were pointed to where the propeller was raised and cast a glow on the marvelous colors created from the various marine organisms that had grown on the propeller over the years. The giant piece of metal was wrapped in wool blankets and sprayed with salt water to keep it moist. The following morning, the propeller and shaft were fitted with soaker hoses, rewrapped in wool blankets and covered with sheets of thick plastic. Before it was removed for conservation, the propeller and shaft began to take on an odoriferous nature, and the crew was ready to say bon voyage to its "shipmate."

The twelve-ton turret was raised from the ocean floor on August 5, 2002, and taken to the Mariner's Museum, where an ongoing conservation program continues. Hundreds of artifacts have since been painstakingly recovered from the turret, including knives, forks, spoons, a key, coins, buttons and a gold ring.

There was an ongoing debate as to where the ironclad's artifacts should be housed. While the USS *Monitor* Center has many on display, others can be seen at the Graveyard of the Atlantic Museum in Hatteras. Through a long-term loan agreement with NOAA and the Mariner's Museum, several small items—such as mustard bottles, silverware, an ironstone dinner plate, a jar of relish and coal—are visual aids on exhibit to help visitors to the Graveyard of the Atlantic Museum interpret the story of the loss of the *Monitor*.

Carpenters Stranded in the Halloween Storm

First off, let's get something straight. The Halloween Storm and the storm that caused a barge to break loose from its mooring and take out a portion of the Oregon Inlet Bridge were two different storms. They did, however, strike the Outer Banks almost exactly one year apart: the Oregon Inlet Bridge incident on October 26, 1990, and the Halloween Storm, which inspired the book *The Perfect Storm*, in October 1991.

My husband was working with Sean Estes and crew (Quinton "The Q" Montgomery, Michael Davison, Chris Lyster and Lester Cobb) in

Salvo. Even our dog, Jake, was at the jobsite. Q recalled, "We were at work all day and we didn't hear anything about it." But when the group stopped at Midgett's Island Convenience just before leaving Rodanthe, the men learned that severe ocean over-wash on Highway 12 would keep them from making the trip home. They got some twelve-packs, cigarettes, bread and a pack of baloney with the cash they had on hand. Estes got a motel room with a credit card for a bunch of guys (some worried about missing Halloween parties) and a black mixed-breed dog.

Up on the northern beaches, I received the news that I would be alone that night and sort of panicked and called my friends for help. One was living nearby on Highview Street, and she let me borrow her dog, Zip Code. Others came to keep me company and brought the game Pictionary. The next morning, I left for work heading east on West Durham Street and found the US 158 Bypass acting as a dyke, holding back at least two or three feet of water. I continued my commute, noticing that the area south of Nags Head Shell was flooded, too. When I got to work at the Outer Banks History Center, I declared it a day of history

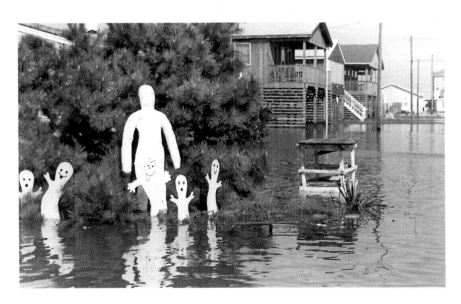

Halloween decorations in the Avalon Beach neighborhood in Kill Devil Hills stand in floodwaters following the Halloween Storm. High tides pushed water in between the beach road and the 158 Bypass. On Hatteras Island, ocean water covered Route 12 in places. *Outer Banks History Center Collections, 1991.*

and urged that some of us be allowed to document it. And we did. We waded all around the Avalon Beach neighborhood and then some, taking photos of the incredible flood tide.

So back to those marooned carpenters. The next morning, "We realized we weren't getting out of there," said Davison, and a one-night strand was all they wanted to endure. He declared that he wasn't staying down there another night, and Lyster agreed. "We had to make it back," said Q. "We didn't have any money. The police said they weren't going to tell us we could go, and they weren't going to tell us we couldn't go. They wished us good luck." So, they left their vehicles and their tools (which was about all they had back then) and walked miles through the Pea Island Refuge, sometimes in patches where the ocean met the sound.

According to Lyster, "Jake dog was with us, and that was my biggest worry when we had to cross the S-Turns. Steve grabbed Jake by the collar to keep him from getting sucked out into the ocean. The tide was really pulling." The Q confirmed Lyster's recollections. "There were places were there wasn't any water, but there were two or three places that there were waves coming by. I bet that dog swam a mile."

While making its way north, the group came upon abandoned vehicles partially buried in the sand and pondered the destinies of the drivers. "You were thinking, how did that person get saved?" There are discrepancies, however, as to the depth of the water, the funny thing being that the taller the person, the deeper they remembered the water. Stevie D. claimed that the water was two or three feet deep. Lyster (who is a bit taller) recounted the water as chest deep, but Q (the tallest of them all) said that it was neck high in places. Davison remembered the water as waist high but admitted, "There were spots where it could be neck high if you weren't watching yourself. It was pretty hairy."

"We walked a long damn ways," said Q. "I had blisters on my feet." On several occasions during their trek, they were passed by state workers driving heavy equipment who weren't allowed to pick up any passengers. Just shy of the Oregon Inlet Bridge, they got a ride from an older man in a pickup truck. "A fisherman I think, either that or a captain. He might have even worked at Oregon Inlet. All of us bailed in there."

After a stop on the other side of the bridge, it was reported that "a nice lady from Oregon Inlet Fishing Center" gave them all a ride to the Whalebone 7-11, where they began to make calls to arrange for rides home. Q pointed out, "That was before cellphones."

So, due to sheer determination, Halloween was celebrated in style, and it was a good thing because some of the guys had spent all week working on their costumes. Davison was the burnt cowboy from the movie *Towering Inferno*. The Q went dressed as a woman, but it was Lyster who won the $150 prize at the Fish Market Restaurant (now Mama Kwan's) as half man/half woman. It was a good thing, too, as he needed the money.

A BRIEF HISTORY OF SKYCO ON ROANOKE ISLAND

Skyco, in the center of Roanoke Island's west side, was first known as Ashbee's Landing and Ashby's Harbor. According to the census, sixty-two-year-old Solomon Ashbee lived there in 1860 with his wife, Mary, fifty-three, and children Samuel, thirty-five; Charles, twenty-nine; Caroline, eighteen; and John, eleven. His real estate was valued at $800 and his personal estate at $12,000. He is listed as a farmer, as is his oldest son, while Charles is listed as a waterman.

In January 1862, General Ambrose Burnside led a flotilla of ships from the Naval Academy down the Chesapeake Bay and stopped at Fort Monroe pick up his orders. The group of eighty vessels continued out to sea, where Burnside read the orders, which were to sail along the coast, enter Hatteras Inlet, sail up Croatan Sound and capture Roanoke Island, which was under Confederate control.

The Confederates had built forts on the north end of the island and blocked the Croatan Sound using a line of old ships and pilings. However, Burnside chose to land at Ashby's Harbor after it was recommended by Tom Robinson, a runaway slave from Roanoke Island. Robinson knew that it was the best natural deep-water harbor on the west side of the island. Burnside sent an engineer, Lieutenant Andrews of the Ninth New York, on a reconnaissance trip to survey the harbor and make soundings to determine the depth of the water.

Within an hour, somewhere between eight and ten thousand men had landed and bivouacked for the night. The following morning, regiments assembled, advanced through thickets and underbrush and waded through knee-deep mud to the middle of the island. The greatly outnumbered Confederates retreated to the north end of the island, where about 2,800 were captured, along with forty-two cannons and 1,500 guns that were described as unfit for military purposes due to their age and inefficiency.

The Ashbee home was used as a hospital during the Battle of Roanoke Island, as was another nearby house, called Hammond House in the official records but which was most likely the Hayman house as the Hayman family lived next to the Ashbees. Solomon Ashbee died in 1867 and was buried on the property. The home was then purchased by Marcus Lafayette Midgette and later passed down to his son, Christopher Columbus Midgette.

For about twenty years, from roughly 1889 to 1907, the steamers *New Berne* and *Neuse* of the Old Dominion Steamship Line stopped at Ashby's Harbor en route between Elizabeth City and New Bern. A dock and warehouses were built at the site. A post office operated there from roughly 1892 to 1913, and it was the post office that assigned the name Skyco to this middle settlement on Roanoke Island. It was named for a local Native American, as were the other Roanoke Island settlements of Wanchese and Manteo.

Jule Day, a wealthy New Yorker who liked to hunt and fish, purchased the Ashbee home in the 1920s. He created Skyco Lodge, dug canals and stocked them with fish and brought in caged and free-roaming animals. He built bridges over the canals, and the whole complex, where he entertained his friends and business associates, had a parklike setting. There were monkeys, peacocks and horses.

In 1926, illustrator Frank Stick, who was drawn to the Outer Banks because of the area's recreational opportunities, vast unspoiled beaches and historic attractions, rented the Skyco Lodge and lived there with his family. Stick's son, David, would grow up to become the leading historian of the Outer Banks and author of a dozen books on local history. In his memoir, *Musings of a Maverick*, David Stick recalled with fondness growing up in this atmosphere, riding horses and playing with the neighbor's children such as the Collins and Midgettes.

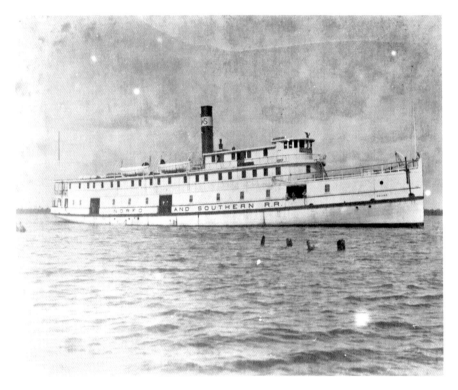

The steamer *Neuse* began making stops at Skyco in 1890. *State Archives of North Carolina, circa 1900.*

An airstrip was created at Skyco in the late 1930s and was used to bring in supplies to the Works Progress Administration and Civilian Conservation Corps project of sand fixation along the beaches. The National Park Service hired pilot Dave Driskill, an aviation pioneer. Driskill later formed the Roanoke Island Flying Service when he and five investors bought a plane to be used for charters and sightseeing tours. These trips proved to be popular; customers got a short ride for only a dollar.

Arthur Louis Midgette, or Louis as he was known, owned a significant amount of land in the Skyco area. Midgette's family roots run deep on Roanoke Island. He was the grandson of Louis Napoleon Midgette, elder brother of Christopher Columbus Midgette. Brothers Louis Napoleon and Christopher Columbus were sons of Marcus Lafayette Midgette, who purchased the Ashbee home from Solomon Ashbee.

Midgette enlisted in the Coast Guard in 1937 when he was eighteen. He later served as superintendent of Elizabethan Gardens for close to thirty years, as well as on the Dare County School Board for more than twenty years. Although he was offered more than $1 million for his property, in the early 1990s, he donated 1,300 acres to the Nature Conservancy for a wildlife sanctuary. This is the open land south of the Nags Head–Manteo Causeway, after crossing the Washington Baum Bridge heading to Manteo. Midgette wanted the Roanoke Island landscape to remain pristine. In 1995, Governor Jim Hunt awarded Louis Midgette with a Wildlife Conservation Award.

To help supply the growing demand for water in Dare County, the Skyco water treatment plant began operating in 1980. The newest addition to Skyco is the University of North Carolina Coastal Studies Institute research and education campus. The fifty-thousand-square-foot building was built according to Leadership in Energy and Environmental Design (LEED) standards and opened in 2012.

Remembering the Laundromats

Change is constant on the Outer Banks. The tide is always changing. The wind moves sand and stirs the waters. Land is being developed, and old buildings are torn down to make way for the new. Another change that has taken place in the past twenty years is the disappearance of the laundromat.

Hatteras Island historian Danny Couch shared the history of the Wash Basket, which was in operation in Buxton from roughly 1965 to 1993. "When the Park Service was in the campground business, it was about the most popular thing going in season and after rain events, but also for folks who didn't have washers and dryers, which was the case with the old homes and the old-style cottages that built our tourist industry."

According to Couch, the Wash Basket, located south of Conner's Supermarket, was started by the late Al and Irene Gammage and was purchased by Garland and Karen Midgette in about 1986. "The place was legendary with the surfers for nearly thirty years and was a part of the fabric (no pun intended) of social life here." He added, "It was actually a

place for the young kids to ride their bikes to and step in and warm up on a cold day. Those old commercial dryers really put out the heat."

The establishment came to its demise after it was flooded during Hurricane Emily in 1993, and Environmental Protection Agency regulations regarding water discharge prevented its recovery.

Mary and Joe Pool owned the Beauty Boutique and the Speed Wash, two of the southernmost buildings on the east side of the US 158 Bypass in Nags Head. It was said that the change machine seldom worked, but if the beauty shop was open, you could get change there. If not, a trip to Whalebone 7-11 was required.

Barbara Creef and her sisters grew up in the area and would meet at the Speed Wash. "Jody, Donna and I would ask for the same day off from our jobs so we could get together and do laundry; the cousins could play together." She remembered kids putting their younger siblings in the square wire carts and pushing them around to keep entertained while mothers folded the wash. "When it was done, we'd

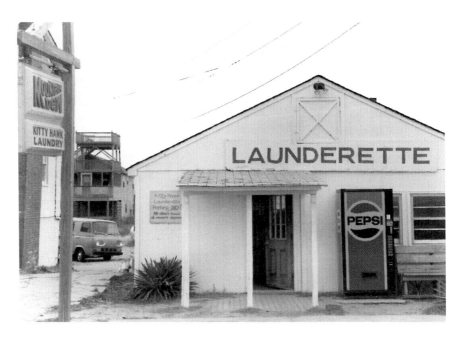

The Kitty Hawk Launderette near Milepost 4 on the Beach Road offered a "Fluff and Fold" laundry service. *Outer Banks History Center Collections, circa 1991.*

pack it in the trunk and hit the beach at Jennette's Pier," she recalled with a smile.

While I patronized most all of the laundromats in Dare, it was the Kill Devil Hills Superette–Launderette (from circa 1967 to the late 1990s) that I frequented most often. It was open twenty-four hours, and I was known to take advantage of an insomnia-filled night to get the washing done. Saturday afternoons were the most crowded, and one of the drawbacks to the Launderette was the disproportionate number of washers in relation to dryers (probably 2:1).

The place could be clannish and downright scary with all the smoking and drinking going on, but I never much worried, being a regular. When the dryers were in short supply, someone would secretly inform a selected recipient that they could "have" their dryer when their load was finished. Also, if any dryer was working particularly well or would run for an extended period of time on just one quarter, this information was also strategically shared.

Because of the crowds at the Superette-Launderette, Hellen Shore Wilson would head to the Outer Banks Mall. She recalled doing the laundry in the late 1980s. "My loyalty turned to the new Nags Head coin-op beside the mall. It was more expensive, but it was spic-n-span, and the washers, dryers and change machine almost always worked. I soon learned the white-haired retiree running the shop, when he said his store closed at 9:00 p.m. on weeknights and 8:00 p.m. on Sunday, meant it." Wilson remembered closing the shop down with the white-haired man on a number of nights, "even after we had discussions on whether he could close the store even if my clothes were not out of the cycle yet."

Nags Head contractor Billy Moseley reminisced, "I used to have my laundry done at the Cavalier Surf Shop and Laundromat, probably back in the mid-1980s. You could still take your laundry there, and they would do it for you. It was a pretty unique setup." Marty Slayton, owner of the Cavalier, said that she did a brisk business with much of the Outer Banks wait staff in the '80s before the service was discontinued. "They would drop their uniforms off in the morning and say, 'I need that tonight.'"

Other laundromats that operated in Dare County were the Nags Head Laundromat (circa 1960s) across from the Nags Head Fishing Pier, Van

Vleek's Kitty Hawk Launderette (circa 1965–90) at Milepost 4 on the Beach Road and a laundromat in Chesley Mall in Manteo (circa 1975–2000). The Speed Wash in Manteo and the Coin Laundry in Kill Devil Hills are the only public self-service laundry facilities in the area today.

SELECTED BIBLIOGRAPHY

Albertson, Catherine Seyton. *Wings Over Kill Devil Hills and Legends of the Dunes of Dare*. N.p., circa 1940.

Ashe, Samuel A. *History of North Carolina*. Greensboro, NC: C.L. Van Noppen, 1925.

Barnes, Jay. *North Carolina's Hurricane History*. Chapel Hill: University of North Carolina Press, 1995.

Barney, R.L. *Further Notes on the Natural History and Artificial Propagation of the Diamond-Back Terrapin*. Washington, D.C.: Government Printing Office, 1922.

Bees, James L., and David Sutton Phelps. *The Carolina Algonkians Archaeology and History*. Belhaven, NC: Belhaven Museum, 1980.

Bell, Edna Evans. "My Birthplace and My Home." Unpublished manuscript, Outer Banks History Center, 1968.

Binkley, Cameron, and Steven A. Davis. *Preserving the Mystery: An Administrative History of Fort Raleigh National Historic Site*. Atlanta, GA: Cultural Resources, Southeast Region, National Park Service, 2003.

Blackburn, Alexander. *Meeting the Professor: Growing Up in the William Blackburn Family*. Winston-Salem, NC: John F. Blair, 2004.

Brimley, Herbert Hutchinson. *A North Carolina Naturalist: H.H. Brimley, Selections from His Writings*. Freeport, NY: Books for Libraries Press, 1971.

Cheatham, James T. *The Atlantic Turkey Shoot: U-Boats Off the Outer Banks in World War II*. Greenville, NC: Williams and Simpson, 1990.

Chenery, William H. *Reminiscences of the Burnside Expedition*. Providence, RI: The Society, 1905.

Coker, R.E., and K. Mitsukuri. *The Natural History and Cultivation of the Diamond-Back Terrapin: With Notes on Other Forms of Turtles*. Raleigh, NC: E.M. Uzzell and Company, 1906.

Crumley, Brian T., and Frank J.J. Miele. *Roanoke Island, 1865–1940: Special History Study*. Atlanta, GA: Cultural Resources Division, Southeast Regional Office, National Park Service, 2005.

Day, David L. *My Diary of Rambles with the 25th Mass. Volunteer Infantry With Burnside's Coast Division. 18th Army Corps and Army of the James*. Milford, MA: King and Billings, 1884.

Duffus, Kevin P. *Shipwrecks of the Outer Banks: An Illustrated Guide*. Raleigh, NC: Looking Glass Productions Inc., 2007.

Dunbar, Gary S. *Historical Geography of the North Carolina Outer Banks*. Baton Rouge: Louisiana State University Press, 1958.

Gillespie, C. Richard. *The James Adams Floating Theatre*. Centreville, MD: Tidewater Publishers, 1991.

Hardy, Marion W. *I Remember When "Oriental."* New Bern, NC: A-1 Special Secretarial Service, 1975.

Harriot, Thomas, and John White. *A Briefe and True Report of the New Found Land of Virginia*. New York: Dover Publications, 1972.

Hewes, Andrew M. *Wright Brothers National Memorial: An Administrative History*. Washington, D.C.: U.S. National Park Service, Office of Archaeology and Historic Preservation, Division of History, 1967.

Hildebrand, Samuel F., and Charles Hatsel. *Diamond-Back Terrapin Culture at Beaufort, N.C.* Washington, D.C.: Government Printing Office, 1926.

Hornaday, William Temple. *Our Vanishing Wildlife: Its Extermination and Preservation*. N.p.: New York Zoological Society, 1913.

Hoyt, Edwin Palmer. *U-Boats Offshore: When Hitler Struck America*. New York: Stein and Day, 1978.

Johnson, Charles F. *The Long Roll; Being a Journal of the Civil War, As Set Down During the Years 1861–1863*. East Aurora, NY: The Roycrofters, 1911.

Khoury, Angel Ellis. *Manteo: A Roanoke Island Town*. Virginia Beach, VA: Donning Company, 1999.

Lawson, John, and Hugh Talmage Lefler. *A New Voyage to Carolina*. Chapel Hill: University of North Carolina Press, 1967.

Lemmon, Sarah McCulloh. *North Carolina and the War of 1812*. Raleigh, NC: State Department of Archives and History, 1971.

Mallison, Fred M. *The Civil War on the Outer Banks: A History of the Late Rebellion Along the Coast of North Carolina from Carteret to Currituck, with Comments on Prewar Conditions and an Account of Postwar Recovery*. Jefferson, NC: McFarland, 1998.

Mitchell, Ehrman B., and Sarah Allaback. *Wright Brothers National Memorial Visitor Center: Historic Structure Report*. Atlanta, GA: Cultural Resources, Southeast Region, National Park Service, 2002.

Mook, Maurice Allison. "Algonkian Ethnohistory of the Carolina Sound." *Journal of the Washington Academy of Sciences* 34, nos. 6 and 7 (1944).

North Carolina Emergency Relief Administration, J.S. Kirk, Walter A. Cutter and Thomas W. Morse. *Emergency Relief in North Carolina: A Record of the Development and the Activities of the North Carolina Emergency Relief Administration, 1932–1935*. [Raleigh, NC]: Edwards and Broughton Company, 1936.

Official Records of the Union and Confederate Navies in the War of the Rebellion. Washington, D.C.: Government Printing Office, 1894.

Powell, William Stevens. *The North Carolina Gazetteer*. Chapel Hill: University of North Carolina Press, 1968.

————. *Paradise Preserved*. Chapel Hill: University of North Carolina Press, 1965.

Powell, William Stevens, and Jay Mazzocchi. *Encyclopedia of North Carolina*. Chapel Hill: University of North Carolina Press, 2006.

Quinn, David B. *The Roanoke Voyages, 1584–1590; Documents to Illustrate the English Voyages to North America Under the Patent Granted to Walter Raleigh in 1584*. London: Hakluyt Society, 1955.

Reaves, Bill, comp. *A Federal Point Chronology 1725–1994*. New Hanover County Library. www.nhcgov.com/Library/Local%20History%20Ebooks/Federal%20Point%20Chronology%201728-1994.pdf.

Saunders, W.O. *A Souvenir Handbook of the Wright Memorial*. Elizabeth City, NC: The Independent, 1935.

State of North Carolina. *Indian Agriculture*. Raleigh: America's Four Hundredth Anniversary Committee, North Carolina Department of Cultural Resources, 1981.

————. *Indian Fishing and Hunting*. Raleigh: America's Four Hundredth Anniversary Committee, North Carolina Department of Cultural Resources, 1981.

————. *Indian Towns and Buildings*. Raleigh: America's Four Hundredth Anniversary Committee, North Carolina Department of Cultural Resources, 1981.

————. *Indian Words and Place Names*. Raleigh: America's Four Hundredth Anniversary Committee, N.C. Department of Cultural Resources, 1981.

State of North Carolina, Department of Archives and History, and David Leroy Corbitt. *The Formation of the North Carolina Counties, 1663–1943*. Raleigh, NC, 1950.

Stick, David. *Graveyard of the Atlantic: Shipwrecks of the North Carolina Coast*. Chapel Hill: University of North Carolina Press, 1952.

————. *Indian Food and Cooking: In Coastal North Carolina 400 Years Ago*. Raleigh: America's Four Hundredth Anniversary Committee, North Carolina Department of Cultural Resources, 1983.

————. *North Carolina Lighthouses*. Raleigh: North Carolina Department of Cultural Resources, Division of Archives and History, 1980.

————. *The Outer Banks of North Carolina, 1584–1958*. Chapel Hill: University of North Carolina Press, 1958.

Tate, William James. *Brochure of the Twenty-fifth Anniversary Celebration of the First Successful Airplane Flight, 1903–1928*. Kitty Hawk, NC, 1928.

Trotter, William R. *Ironclads and Columbiads: The Civil War in North Carolina— The Coast*. Winston-Salem, NC: J.F. Blair, 1989.

Tucker R. Littleton. "When Windmills Whirred on the Tar Heel Coast." *The State*, October 1980.

Wilmington Morning Star. "Ohioan Top Angler in Governors Party." June 29, 1957.

ABOUT THE AUTHOR

Sarah Downing has made her home on North Carolina's Outer Banks for more than twenty-five years. She was drawn to the natural beauty and open spaces that the land and sea provided, but she quickly became immersed in the history and lore of her adopted home as well. Since 1991, Sarah has been associated with the Outer Banks History Center in Manteo, where she currently serves as assistant curator. A certified North Carolina librarian, Sarah enjoys

Photo by Wilton C. Wescott.

writing, cooking, beachcombing, surfing and taking walks in the many the natural areas of the Outer Banks. She lives in Nags Head with her husband and a mixed-breed dog. *Hidden History of the Outer Banks* is her third book.

Visit us at
www.historypress.net

This title is also available as an e-book